iPhone®
Photography & Video
FOR
DUMMIES®

by Angelo Micheletti

WILEY

Wiley Publishing, Inc.

iPhone® Photography & Video For Dummies®

Published by
Wiley Publishing, Inc.
111 River Street
Hoboken, NJ 07030-5774

www.wiley.com

Copyright © 2010 by Wiley Publishing, Inc., Indianapolis, Indiana

Published by Wiley Publishing, Inc., Indianapolis, Indiana

Published simultaneously in Canada

For general information on our other products and services, please contact our Customer Care Department within the U.S. at 877-762-2974, outside the U.S. at 317-572-3993, or fax 317-572-4002.

For technical support, please visit www.wiley.com/techsupport.

Wiley also publishes its books in a variety of electronic formats. Some content that appears in print may not be available in electronic books.

Library of Congress Control Number is available from the Publisher.

ISBN: 978-0-470-64364-8

Manufactured in the United States of America

10 9 8 7 6 5 4 3 2 1

WILEY

About the Author

Angelo Micheletti has had a lifelong passion for photography, starting out with a Kodak Brownie 8mm camera as a youth and graduating to a 4x5 camera with a digital back as his skills and interests progressed. The owner of Scenes from The West (www.scenesfromthewest.com), Angelo combines his love of photography with an easy-to-understand writing style (and a devotion to the Mac since its inception in 1984) to produce well-received lectures, Apple Macintosh training courses and books, and regular updates to his Web site blog. His *iPhoto '09 For Dummies* was published in 2009.

An Apple iPhone Developer, he has an MBA from St. Mary's College in California and currently resides in Bend, Oregon.

Dedication

This book is dedicated to my family, who gave me encouragement and support throughout this endeavor, and to all veterans who, like me, served their country and appreciate the wonderful blessings of being an American. In particular, I dedicate this book to a great friend and lifelong Marine, Robert W. Armstrong, whose insights and conversations I truly enjoy. And to all my friends who offered suggestions and advice, I offer my wholehearted thanks.

Author's Acknowledgments

First of all I want to thank Carole McClendon, my agent, for continuing to find wonderful writing opportunities for me and for her guidance throughout the process.

Thanks goes to my Senior Project Editor, Mark Enochs for his suggestions and advice; to Acquisitions Editor Kyle Looper for many productive and enjoyable discussions, Copy Editor Brian Walls, Technical Editor Dennis Cohen, and the entire Wiley Publishing production team for their professionalism.

Thanks to those who buy this book. True to what I was taught as a youth, learning *is* a lifetime occupation; enjoy every minute of it.

Publisher's Acknowledgments

We're proud of this book; please send us your comments through our online registration form located at http://dummies.custhelp.com. For other comments, please contact our Customer Care Department within the U.S. at 877-762-2974, outside the U.S. at 317-572-3993, or fax 317-572-4002.

Some of the people who helped bring this book to market include the following:

Acquisitions and Editorial

Senior Project Editor: Mark Enochs

Acquisitions Editor: Kyle Looper

Copy Editor: Brian Walls

Technical Editor: Dennis Cohen

Editorial Manager: Leah Cameron

Editorial Assistant: Amanda Graham

Senior Editorial Assistant: Cherie Case

Cartoons: Rich Tennant
(www.the5thwave.com)

Composition Services

Project Coordinator: Sheree Montgomery

Layout and Graphics: Joyce Haughey, Kelly Kijovsky, Christin Swinford

Proofreader: Toni Settle

Indexer: Potomac Indexing, LLC

Publishing and Editorial for Technology Dummies

Richard Swadley, Vice President and Executive Group Publisher

Andy Cummings, Vice President and Publisher

Mary Bednarek, Executive Acquisitions Director

Mary C. Corder, Editorial Director

Publishing for Consumer Dummies

Diane Graves Steele, Vice President and Publisher

Composition Services

Debbie Stailey, Director of Composition Services

Contents at a Glance

Table of Contents

Introduction

*P*icture this: You're out driving and completing errands you need to accomplish or maybe just enjoying the scenery when, all of a sudden, a scene captures your imagination and has you saying, "Wow, I've got to stop and take a photo." Unfortunately, you hadn't intended to take any photos when you started your drive and, of course, you left your camera behind!

Sound familiar? It's probably happened to each of us at some time or another. But what if there was a device you carried with you all the time that also has a built-in camera? Well, if you bought this book, you probably have that device: the iPhone. It may not produce photos at the same level as top-of-the-line digital cameras, but if you're lucky enough to have an iPhone 4 with a 5-megapixel camera, you may be surprised at the results. And as the accomplished photographer Chase Jarvis once said, "The best camera is the one that's with you."

My goal in this book is to make your iPhone camera experience and the photographs you take the best that they can be. And you're going to have fun doing it.

About This Book

In this book, I show you how to use your environment, lighting, and equipment to ensure you capture (digitally) what you see with your eyes. Key areas I discuss include

- ✔ Understanding the photographic and video capabilities of the iPhone camera and its interface
- ✔ Adjusting to your photographic environment
- ✔ Using iPhoto '09 to enhance your photos, import photos to your iPhone, and export photos from your iPhone
- ✔ Improving your chances of capturing the scene you want via iPhone accessories that provide a stable camera platform, external lighting, and so on. Of course, if you have an iPhone 4, you have a built-in flash to work with, too.
- ✔ iPhone apps that make your photos more professional looking
- ✔ Searching the many apps available in the App Store
- ✔ Making electronic photo sharing easier and more fun

I show you techniques that are useful and rewarding when using any digital camera that are especially powerful for iPhone camera photography. Although not written as a digital photography guide, this handy reference is full of information that will make your photography more enjoyable and rewarding. And if you have the e-book version, you'll always have this information available on your iPhone.

Conventions Used in This Book

Before you begin your journey into the wonders of iPhone camera photography, I need to discuss how I present information to you in this book.

- For all Macintosh software (such as iPhoto '09), the primary shortcut keys used are the Command (⌘) key, the Option key, and the Control key. At times, the Shift key is used. These keys are used in conjunction with other keys as shortcuts for menu selections and for invoking various commands (for example, ⌘-0, ⌘-1, ⌘-P). Just remember making a shortcut work requires that you hold down the first key(s) while pressing the last key.

- Some software, such as iTunes, comes in a Windows PC version. For Windows, the primary shortcut keys are the Alt key, the Ctrl key, and the Shift key. Similarly, any shortcut in Windows requires you to hold down the first key(s) and then press the last key to make the shortcut work.

- Menu commands are given in the order in which you select them: for example, Choose File⇨New Playlist means you select the File menu and then choose the New Playlist command.

- Options in dialogs use initial caps even if they aren't capitalized on your screen to make it easier to identify them in sentences. For example, what appears as "Check for iPhoto updates automatically" in a dialog will appear as Check for iPhoto Updates Automatically in this book.

- Web site addresses appear like this: www.scenesfromthewest.com.

- Contextual menus appear from time to time when I describe Mac or Windows software. They appear at your cursor's position when you right-click (or for those with a one button mouse, Control-click or Alt-click) your mouse.

- Features and options differ among the various versions of the iPhone. I state when a functionality I describe is unique to a certain iPhone. If there is a way to accomplish a task with a method that works on all iPhones, I provide that, too.

Foolish Assumptions

I make a minimum of assumptions about you. However, some are inescapable. I assume that

- ✐ You have an iPhone and iTunes running either on a Macintosh or a Windows PC.

 If you have an iPhone 4 running the latest software, everything in the book will apply. If you have an iPhone 3G/3GS or the original iPhone, some functions and descriptions may not apply and are noted.

- ✐ You're familiar with a Macintosh or a Windows PC, specifically, using menus, dialogs, and windows; can open and close files; and can navigate the computer's environment.

- ✐ If you have iPhoto, you're using the version of iPhoto for which this book is written — iPhoto '09. Some capabilities that I describe work in multiple versions of the software but others may not. It would be impossible to describe every possible type of photographic software, so I concentrate on iPhoto, which only runs on a Mac.

How This Book Is Organized

This book contains five parts, each divided into several chapters. Each chapter is then divided into smaller pieces to help you quickly find the information you're looking for.

The book covers a logical progression of subjects, and I encourage you to take advantage of all the information available. That said, I've written it so that you can read any section without necessarily knowing what I cover in previous sections. If you're curious about a particular subject, find the chapter you need and go there directly.

Part 1: Taking Photos and Video on Your iPhone

In these first three chapters, you dive right in and familiarize yourself with the iPhone Camera application — learning the controls, seeing the differences among the iPhone models, and becoming comfortable with the interface. You also take your first photo with your iPhone, practice importing and syncing photos, and share your photos online.

You also shoot video with your iPhone 4 and iPhone 3GS (sorry, the iPhone 3G doesn't do video), edit video (right on the iPhone 4 and iPhone 3GS), and

share your videos with your friends and relatives. I point out areas where the various iPhones differ in capabilities, and, where possible, show you how to work around any limitations.

Part II: Making the Best Use of Your iPhone Camera

You may already know some of the factors that can affect your photo-taking experience. In Part II, I take you through critical differences between a standard digital camera and your iPhone's camera that you may not know. Factors unique to the iPhone camera that you must adjust for can make or break your photographic experience. I also show you how to work with your location's impediments to get the best photos you can.

A good software package often makes a good photograph a spectacular one. In this part, I open up the world of editing with iPhoto '09, from guiding your photo corrections with the histogram to making adjustments for color cast, exposure, saturation, sharpening, and a host of other factors.

Part III: Picking Great Accessories

In this part, I show you equipment made expressly to alleviate some of the shortcomings of a phone-mounted camera, such as stability (or lack thereof) and the absence of a built-in flash (except with the iPhone 4). Some advantages of these accessories include their small size and that they don't require you to carry anything extra to use them because you always have your phone with you.

Additionally, you discover how to show off your pics and photographic skills when there's no computer around.

Part IV: Understanding the Helper Applications

If you've had an iPhone for any time at all, I'm sure you're aware of the diversity and number (with more than 200,000) of the apps available in the iTunes App Store. In this part, I show you photography apps I've worked with that lessen hand-held camera shake, allow you to crop your photo, apply Photoshop-type editing techniques, simulate flash (if you're not lucky enough to have an iPhone 4 with flash built-in), and selectively color a black-and-white photo.

If this sounds like all work and no play, think again. I also show you apps that let you swap the faces within a photograph and get photos onto Flickr, Facebook, or Shutterfly.

Part V: The Part of Tens

Traditionally, the last part of a *For Dummies* book is its Part of Tens, whose chapters each contain . . . you guessed it, ten items. This book is no exception.

In Chapter 11, I identify and describe ten terrific Web resources and software add-ons that can help make your iPhone photography experience even more rewarding. This list includes blogs, forums, and great Web sites that keep you abreast of all that's happening in the iPhone camera world.

Chapter 12 presents ten helpful hints, tips, and shortcuts aimed at making iPhone photography more rewarding in your personal life.

Icons Used in This Book

Icons appear throughout this book in the left margin to provide extra and often vital information regarding the topic at hand. Here's what the ones I use look like and convey to you:

Shortcuts and ideas that can help you produce better photographs or keep you from doing extra work. They're often undocumented operations that I discovered during my years as a professional photographer and want to pass on.

Reminders of what *not* to do or what will happen if you perform an action. They may not always discuss detrimental actions, but you should at least slow down and tread lightly.

Material that reinforces information you need to retain. For these topics, it's going to be important later.

Material you don't have to read, but I assure you is interesting and informative. This material can vary from information about camera formats and what they mean to how the camera and the eye see things differently and how that can affect your photos.

Where to Go from Here

I didn't write this book thinking that you would just sit down and read it from cover to cover in one sitting, but you certainly can do that.

If you prefer to take things a little slower, where you start in the book really depends on your experience with the iPhone camera. If you're familiar with the layout and functionality of the iPhone, you can start with Chapter 2 and begin taking photos or go to Chapter 3 and start shooting video.

If you just want to look at some advanced editing capabilities in iPhoto '09 and understand the best way to use the iPhone camera, you can jump to Chapters 4 through 6 and start there.

The book is ordered in a way I think makes sense, but each chapter stands on its own. That said, you may have to go to other chapters from time to time to review a particular technique or area of the iPhone being discussed.

First and foremost, there's no amount of reading that can substitute for getting out and using your iPhone camera. That experience and feedback along with the tips and photographic knowledge contained in this book will have you enjoying your photography more than ever. The book is up to date as of the time of printing. Any pertinent changes to this book due to subsequent updates to iOS 4 can be found at `www.dummies.com/go/iphone photo`.

Part I
Taking Photos and Video on Your iPhone

The 5th Wave — By Rich Tennant

©RICHTENNANT

"Okay, the view's just up ahead. Everyone open up the Camera app and get ready to be dazzled."

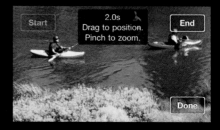

So you're the proud owner of an iPhone! Whether it's an original iPhone model or a 3G, 3GS or the iPhone 4, you need a good understanding of what the various parts are, what they can do, and how you use them.

The first chapter gives you an overview of the iPhone interface to get you comfortable with your iPhone. I show you the differences among the iPhone versions for getting around in the Camera app, shooting video with your phone, and importing and syncing your photographs. Additionally, I introduce you to the wonderful world of geotagging.

All the reading and researching in the world isn't going to make you proficient in using the iPhone camera. You need to get your feet wet, so to speak, and that's what Chapter 2 is all about. I guide you in the best way to take photos with the iPhone and have you actually take one. After you understand the essentials, I take you on a tour of the Photos application on your iPhone.

In Chapter 3, I crank things up a notch and look at using the iPhone camera to take video. I cover the basics of capturing video, editing video on the iPhone itself, and sharing your videos with friends and family.

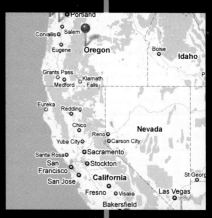

1

Presenting the iPhone Camera

As a professional photographer, I've learned (the hard way, I might add) that anytime you leave your camera at home, you'll need it to capture a spectacular scene you've never before witnessed. It's a solid gold, guaranteed, take-it-to-the-bank fact.

We know the iPhone is a fantastic smartphone. With a built-in camera (and on the iPhone 4 a built-in LED flash) and software, it can also bring great joy by making digital photography available, in your pocket. If you're like me, you never go anywhere without your iPhone. I've been taking photographs for a number of years, and the advent of the digital age is truly a wondrous event. No more running out of film or wondering whether I've captured the shot only to discover later that I didn't.

The resolution of the iPhone camera isn't as high as some digital cameras you might have seen, but as I show you in this book, good photography isn't just about megapixels.

Let me show you how to get the most from your iPhone camera. Throughout the book, I try to show you the differences in iPhone models where they are important. However, the assumption is you are running the latest Apple iPhone software, which is iOS4.

The Big Picture

Some of you remember a time when cameras were big and bulky, you had to remember to buy film before heading off on vacation, and you had to find a

phone booth along the road to speak with someone while driving. The idea of someone being able to call you while you were away from your home telephone was unheard of. The rest of you will have to imagine what it was like.

Flash forward to today. Electronic devices and digital cameras, especially the iPhone, can fit in a shirt pocket or purse. Additionally, the iPhone allows incoming and outgoing calls and the sending of messages with photos and videos to virtually anywhere. Showing you how to harness that photographic power is what this book is all about.

In some ways, the name iPhone is misleading. When someone asks me what I think of it, I usually say something like, "It has wonderful applications, takes photos, allows me to shoot and edit video, answers to voice commands, browses the Web, deals with my e-mail, and oh yes, I can use it as a phone." Best of all, for our purposes, an iPhone interfaces seamlessly with iPhoto, the photo-editing program for Mac. That means, in addition to all the photo options, you can also take advantage of iPhoto's capabilities to enhance your images!

If you have an iPhone 4 or 3GS, you can geotag your photos automatically when you capture them with the preloaded Apple Camera app. Never again will you have to wrack your brain remembering at which vacation spot you took the photo of a lifetime.

In Chapter 5, I show you how to use iPhoto '09 to make prints, edit images, share your photos on social networking sites, and turn your snapshots into artwork for calendars and greeting cards. Many of these tasks can be done directly from the iPhone — it's quite a powerhouse.

Okay, enough praise, let's see how the amazing iPhone camera does its stuff.

Understanding What the iPhone Can Do

The iPhone's capabilities are truly amazing. With an iPhone, you can take photos, handle e-mail, and browse the Web while you're on the go, and each iteration of the hardware and software outperforms the previous version. Additionally, with more than 200,000 applications in the App Store, you'll find hundreds of apps that enhance the photographic capabilities of your iPhone's camera. I discuss a few of my favorites in Chapters 9 and 10.

The iPhone performs photographic magic in two areas:

✒ **Capturing:** The main function of the iPhone camera (or any other camera for that matter). This is the first step you take to obtain the photograph you have in mind when you click the Shutter button. Being the first step, it is imperative that you capture the image properly. Attempting to fix a poorly taken photo later is usually a lost cause. In this book, I help you maximize the quality of the photo you start with.

✓ **Displaying/Sharing:** It's only natural that you want to share your photographic triumphs with family and friends, and your iPhone can help here as well. Whether you want to e-mail photos of the new baby to Uncle Richard or you want to share those photos with others on the Web, your iPhone makes displaying and sharing photographs easy.

What about editing, you might ask? The truth is that no camera, no matter how exotic and no matter the price, edits photos (although if you've upgraded to iOS4, the iMovie for iPhone app you can purchase in the App Store does edit video; more on that in Chapter 3). For that you have to use software, and in the case of the iPhone, you can either get software from the App Store (I show you some iPhone editing apps in Chapter 9) or use software on your Macintosh (or Windows PC). In this book, the external software I describe is iPhoto '09, which only runs on the Mac. For the Windows environment, a very good application is Photoshop Elements, which is a lower cost Adobe product that achieves very good results.

Looking at iPhone model differences

Not all iPhone models are created equal. Some have features that others don't. Here's what the different iPhone models can do:

✓ **Original iPhone:** This version has a 2-megapixel fixed-focus camera for still photography but no video capability. It has neither 3G network capability nor GPS. Instead, it relies on Wi-Fi/cell tower triangulation to approximate its position.

✓ **iPhone 3G:** This model comes in black or white and has a plastic, rather than aluminum, back. It's 3G network–capable, with built-in GPS, a 2-megapixel fixed-focus camera for still photography but no built-in video capability and longer battery life.

✓ **iPhone 3GS:** This model has all the features of the 3G, a built-in compass, and a faster processor. The camera is 3 megapixels instead of 2, has autofocus, automatic white balance, and macro capability. It also records video and has some video-editing capability.

✓ **iPhone 4:** This iPhone has all the features of the 3GS and then some. New features include an Apple A4 1Ghz processor, a three-axis gyro, a 5-megapixel camera with LED flash, a front-facing VGA camera for video chats, video recording capability in HD 720P, a high-resolution retina display (960 x 640 pixels), and longer battery life.

The iPhone 3G, 3GS, and 4 all have built-in GPS, which is great for finding your way to a particular destination. However, GPS serves another function on these iPhones. When you take a photograph with the provided Camera app, the photo is saved with the GPS location where you took the photo, which is called *geotagging*. (See the right side of Figure 1-1.) The pin in the figure shows the location.

When you import your iPhone photos into iPhoto '09, the geotagging information is copied, too. Other software programs can geotag as well, including Photoshop Elements. Best of all, you don't have to do anything, it's automatic. Never again will you wonder, years later, where on earth you took a particular photo.

You can turn this feature off: Open the Settings app on your Home screen, tap the General entry, and then tap the Location Services entry.

On the next screen, you can turn the Location Services button to On or Off by sliding it to the right or left. If you choose On, the individual apps that request location information display and you can individually turn their access to location services on or off (see the left side of Figure 1-1).

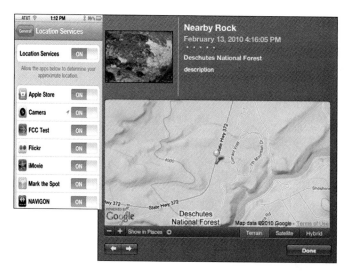

Figure 1-1: A geotagged photo in iPhoto '09 and Location Services buttons.

Taking pictures with the Camera app

Your iPhone has a Camera app (found on your Home screen) that allows you to take photographs — on the 3GS and 4, you can shoot video, too. In Figure 1-2, you see my Home screen and the icon for the Camera app.

The iPhone lets you move application icons around, so your Home screen may look different from the one shown.

Your iPhone also comes with a Photos app (see Figure 1-2) that contains photo albums you have created and something called Camera Roll (see Figure 1-2). Camera Roll acts as the repository for all the photos and videos currently stored on the iPhone in capture order. Tapping a thumbnail brings the photo up, ready to be shared, deleted, or left alone.

Camera app

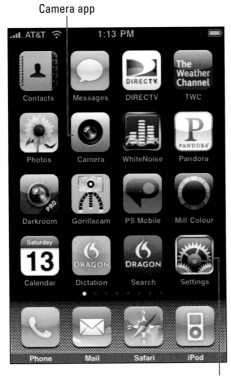

Settings app

Figure 1-2: My Home screen.

To see the Camera app interface, tap the Camera icon one time on your iPhone. In Figure 1-3, you see the "look and feel" of the Camera application on the iPhone 4 (left) and iPhone 3GS (right).

Figure 1-3 was taken just before the application opened. The controls are at the bottom. From left to right, here's what these controls do:

- **Thumbnail of last photo taken:** Tapping this thumbnail displays the photo onscreen along with the controls for scrolling through other photos on your Camera Roll.

- **Shutter button:** Tapping this button captures whatever's displayed on your screen as a photograph. The captured photo displays in the thumbnail at the lower left.

Change Camera button

Flash Selector button

iPhone 4 iPhone 3GS

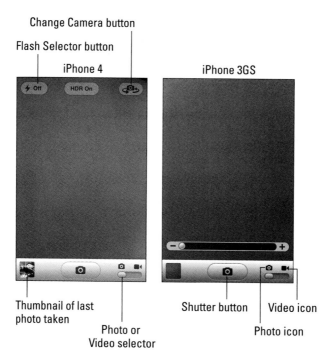

Thumbnail of last Shutter button Video icon
photo taken
 Photo or Photo icon
 Video selector

Figure 1-3: The Camera app's Photo interface.

To take a photo or begin a video, use the button at the bottom center of the Camera interface (see Figures 1-3 and 1-4) which is called the Shutter/Record button. This is a virtual button and operates on the *release* of your finger. So to take a photo or start a video just hold your finger on the button, frame your photo as you wish, and then lift your finger to take the picture.

📌 **Photo or Video selector (4 and 3GS only):** By default, the iPhone 4 and 3GS take a photograph when the Shutter button is tapped. If you slide the selector toward the video camera icon, the iPhone 4 and 3GS interfaces change the center button to a red Record button (see Figure 1-4). Press and release this button to start recording video of whatever appears on your screen. Press and release the button again to stop recording video.

📌 **Flash Selector, HDR, and Change Camera Button:** The iPhone 4 has an LED flash. The Flash Selector button appears in the top left of your screen. Just tap it to make a selection. Settings include Auto (the camera chooses when flash is needed), On (flash fires for every photo), or Off (flash never fires). The HDR button helps with high contrast scenes.

At the top right of your screen is the button you tap to change from the rear-facing camera to the front-facing camera and back again (yes Martha, now it's easy to take your own photo).

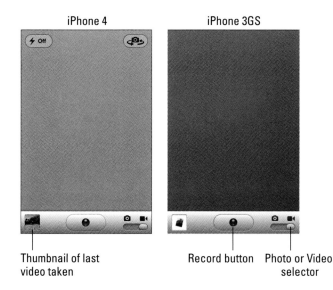

Figure 1-4: The Camera app video interface for iPhone 4 (left) and iPhone 3GS (right).

You discover more about these capabilities and other things you can do with your photos in Chapter 2.

Capturing video on the iPhone 3GS

Here's a closer look at the video interface on the iPhone 4 and 3GS. In Figure 1-4, you see the iPhone 4 on the left and the iPhone 3GS on the right. Both images show a red Record button in the control panel at the bottom of the screen. To capture a video, follow these steps:

1. **Press and release the Record button to start recording.**

 The iPhone 4 and 3GS starts recording video. Remember the built-in microphone is also recording audio, so be careful about what you say. However, if you prefer, you can narrate your video while you capture it.

2. **Press and release the Record button again to stop recording.**

 While you capture video, the Record button blinks to let you know your camera's recording. When you stop recording, the Camera app puts an image of your video into the thumbnail.

3. **Tap the thumbnail to see the last video taken.**

 You see the first frame of the video (as shown in Figure 1-5) along with a strip at the top of the screen showing all the frames of the video. You can now play the video, edit it, or discard it. Chapter 3 covers all these functions in detail. But that's basically all it takes to capture video on this wonderful device.

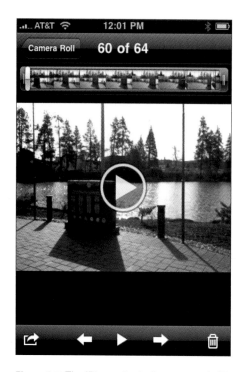

Figure 1-5: The iPhone displaying captured video.

Importing and transferring your photos

If you've been wondering whether the USB cable/iPhone connector you got with your iPhone is good for anything other than charging your iPhone, the answer is yes. You use it to connect to your computer to import and sync photos and video. Importing is transferring files from your iPhone into your computer or photo-editing software, such as iPhoto or Photoshop Elements. Syncing, in this case, is processing photos between your computer and your iPhone using iTunes.

The iPhoto import process

Say you have photos and perhaps a video (if you have an iPhone 4 or 3GS) that you want to transfer to your computer.

If you're familiar with iPhoto, you know that the highlighted photos and videos transfer to the iPhoto Library where the images can be edited. Videos can be edited in QuickTime or iMovie. I describe the editing process in detail in Chapter 6.

If iPhoto '09 is running on your computer and you connect your iPhone to your computer, you will see a screen similar to Figure 1-6. You see all the photos and videos that are in your Camera Roll. You can import all of them, by clicking the Import All button, or select only the ones of interest and click the Import Selected button. Once this is done your photographs are safely stored in the iPhoto Library.

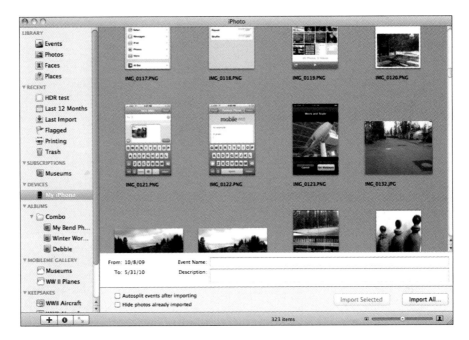

Figure 1-6: iPhoto '09 ready to import from iPhone.

For more details on this and other processes within iPhoto '09, check out iPhoto '09 For Dummies.

Syncing with iTunes

To get photos from your computer to your iPhone, you use Apple's iTunes which is available for both Macs and Windows PC. iTunes allows you to either select photos from iPhoto or a folder on your Mac or PC. (Figure 1-7 shows a Mac example.) Because I selected the radio button for Selected Albums, Events and Faces, and Automatically Include No Events," all events in the iPhoto Library are listed, but only the ones I choose will be transferred to the iPhone's Photo Library as Photo Albums. This process is described in more detail in Chapter 2.

Editing your photos and video

After you shoot photos and videos, it's only natural to wonder how you might edit them. First, you need to import them from the iPhone to your photo-editing software that ordinarily runs on your Mac or PC. To transfer photos from the iPhone, connect the iPhone to your computer and then use any of the following programs to transfer and customize your photos:

✔ iPhoto '09

✔ Photoshop Elements

✔ Scanner and Camera Wizard

✔ Image Capture/Aperture

✔ Lightroom

In this book, I use iPhoto '09 to import from the iPhone and edit, but many other equally competent software packages exist.

Figure 1-7: Transferring photos to the iPhone in iTunes.

Setting the slideshow controls

Part of the fun of using your iPhone to take photographs and videos is showing the images off to your family and friends. I show you several ways to do this in Chapters 2 and 3, but there's an easy way on your iPhone. You can create a slideshow using the Photos app.

First tap the Settings icon (see Figure 1-2), scroll down and tap the Photos entry (see Figure 1-8) to see a screen for setting your slideshow parameters.

Figure 1-9 shows you the screen that allows you to set performance parameters for your slideshow.

Figure 1-8: The Settings screen on the iPhone.

Figure 1-9 shows where you can set the display time for each slide, choose a transition effect, and toggle the Repeat and Shuffle options.

When you want to play a slideshow:

1. Tap the Photos application icon on the Home screen.

A screen similar to the leftmost screenshot (Albums) in Figure 1-10 appears.

By tapping Camera Roll or Photo Library, you can proceed to choose your photo.

.ul... AT&T 📶 12:34 PM ✳ 🔋

‹ Settings **Photos**

Slideshow

Play Each Slide For 5 Seconds ›

Transition Dissolve ›

Repeat OFF

Shuffle OFF

Figure 1-9: Setting the Slideshow parameters screen.

Figure 1-10: Albums, Events, and Places screens.

If you want to see your photos grouped by events, tap the Events icon at the bottom of the screen (as shown in the center screenshot of Figure 1-10) and select your photo from an event. If you want to see where your photos were taken, tap the Places icon. As shown in the rightmost screenshot in Figure 1-10, the pins denote locations where you took a photo. Tapping a pin shows how many photos were taken there. Tap the pin again and the photo's thumbnails display.

2. **Choose any of the photo albums, events, or places listed.**

3. **Select the photo you want the slideshow to start with and then tap the Play button (circled in red).**

An example is shown in Figure 1-11. More on slideshows in Chapter 2.

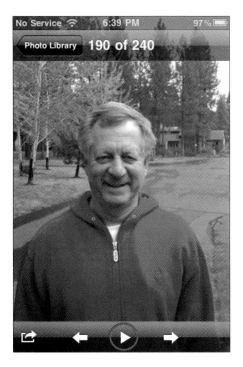

Figure 1-11: Example slideshow screen.

Picking the uses for your photographs

An action icon (with a curved arrow) appears in the bottom-left corner when you select a photo from the Camera Roll or one of your albums (refer to Figure 1-11). The icon lets you choose the destination of your photo.

Figure 1-12 shows your choices. I delve in to the heart and soul of these choices in Chapter 2, but here's a brief look at the interface you see when you tap each button.

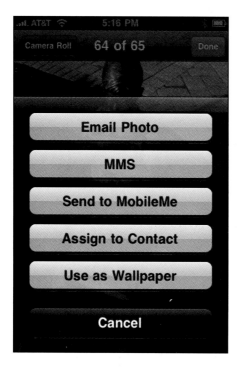

Figure 1-12: Destination choices.

Figure 1-13 shows an example of the screen that appears when you tap the "Email Photo" button. A new e-mail message form is presented with the photo embedded in the text area. Fill in the addressees, the subject, and any comments, press Send, and it's on its way.

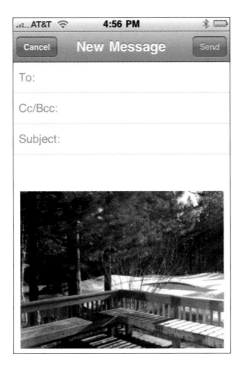

Figure 1-13: E-mail the photo.

Similarly, tapping the MMS button in Figure 1-12 presents you with a new MMS message form with the photo embedded. An example is shown in Figure 1-14. Just fill in the addressees and tap the Send button.

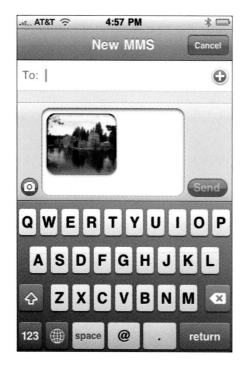

Figure 1-14: Send the photo with an MMS message.

To select the Send to MobileMe option you must have a MobileMe account. Figure 1-15 shows the screen where you enter a title and description of the photo and choose an album where it will be stored. (The album must be created in MobileMe prior to adding the photo.) Tap the Publish button and the photo will be sent to the album indicated, ready for viewing on MobileMe.

The Assign to Contact button provides a list of your Address Book contacts. Simply click a contact, and the photo will appear next to the person's name in the Address Book, and in the upper-right corner of any e-mail sent or received from that person.

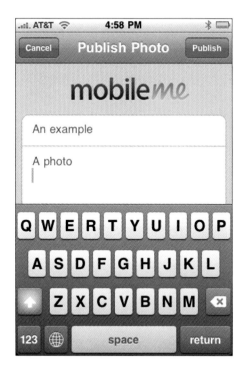

Figure 1-15: Send the photo to a MobileMe account.

If you tapped the Use as Wallpaper button, you see a screen similar to Figure 1-16 with your photo displayed. Use your finger to move the photo within the bounds of the upper and lower black bands. You can use the standard pinch and unpinch motions to zoom in on or out of the photo. When satisfied, tap the Set Wallpaper button.

These five choices in the Destination screen are a very convenient way to send any photograph on your iPhone to many destinations.

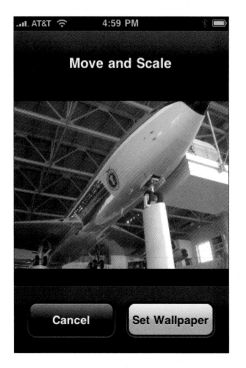

Figure 1-16: Use the photo as wallpaper.

Touring the iPhone Interface

A look at the iPhone 4 hardware can get you familiar with the function buttons so that when the perfect shot is all lined up, you don't forget where they are. Figure 1-17 shows the locations of the Home button, both cameras, and the LED flash on the iPhone 4. These are the only hardware controls concerned with photography.

Front view

Here are the controls you find on the front of your iPhone:

✔ **Sleep/Wake:** Press this top-mounted button to turn off the iPhone screen. Putting the screen to sleep saves the battery and is a good thing to do when you finish your iPhone session. If you press and hold this button, the Power Off slider appears, allowing you to completely power down the iPhone.

To power up the iPhone, press and hold the Sleep/Wake button until you see the Apple icon appear onscreen.

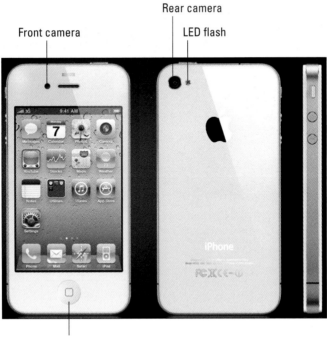

Front camera

Rear camera

LED flash

Home button

Figure 1-17: Front and rear views of the iPhone 4.

✔ **Home:** Press this button when the iPhone is powered up, and the Slide to Unlock slider appears. Sliding it brings you to either the Home screen or the entry screen for your pass code if your iPhone is set to require one.

Ever wanted to capture a picture of whatever's displayed on your iPhone screen? You can by pressing the Sleep/Wake and Home buttons simultaneously and then releasing them. The new shot of your screen is placed in your Camera Roll.

✔ **Ring/Silent:** Move this button toward the rear of the iPhone to silence the ringtone and use only vibration to alert you to a phone call.

✔ **Volume Up/Down:** Press the top Volume button to increase volume; press the bottom one to decrease it.

Back view

In the upper-left corner of the iPhone is the camera lens (for the iPhone 4, the LED flash is located next to the lens). Be sure not to accidentally cover any part of these with your finger unless you want some terribly dark photos of your finger.

Taking Photos with an iPhone

In This Chapter

▶ Learning how to hold the iPhone to shoot photos

▶ Taking your first photo

▶ Understanding the iPhone's autofocus feature

▶ Creating a slideshow of your photos

▶ Sharing your photos with friends and family

After you get a feel for the iPhone camera, it's time for some practice. What might seem new to you now becomes second nature very quickly. In this chapter, you take your first photograph with your iPhone and you complete a simple project using the Camera app extensively.

There's no better way to reinforce what you read in this book than jumping in and putting that knowledge to use. I give you the benefit of my experience as a photographer and show you how to make picture-taking on the iPhone an exciting and rewarding experience. I guide you through the steps for sharing your photos, and pass along some tips to help make your photos look the best they can.

Taking Your First Photo

Someone more famous than I once said the best place to begin is at the beginning. Let's do that by learning how to hold the iPhone. I don't mean how to hold it while making a phone call — you know how to do that. I'm talking about the best way to hold your iPhone when taking photographs.

The iPhone's size makes the iPhone a breeze to carry; it also makes it difficult to hold securely and steadily. I don't know about you, but I have fairly big hands. Holding the iPhone securely and steadily is not a problem but doing so while leaving the iPhone camera (and if you have an iPhone 4, the LED

flash) unimpeded can be a different story. You can hold your iPhone for photography in portrait or landscape mode, and here's my recommended method for both orientations.

Taking a portrait photo

Holding your iPhone in a vertical or portrait orientation isn't only for taking portraits, even though that's often what it's used for. Some scenes just look better in portrait mode. The main thing is to hold the phone still, and here's how you do that.

1. **Make sure your iPhone is powered on and the Camera app is running.**

2. **Holding the iPhone vertically, point the lens at the subject you wish to photograph.**

 If you're right-handed, you'll probably hold the iPhone in your left hand. If you're left-handed, you'll hold the iPhone in your right hand.

3. **Bring your free hand up, and let it wrap over and around the back of the hand holding the iPhone. (See Figure 2-1.)**

Figure 2-1: Holding the iPhone vertically.

4. **To steady your aim, relax your arms and push your elbows into your body so they act like the legs of a tripod.**

 This methodhelps to steady the iPhone — unless you're like me and have had way too much coffee, in which case, a real tripod is the only cure. More on that in Chapter 6.

5. **Position your iPhone so that the onscreen image is framed the way you want to capture it.**

6. **Hold as still as possible (sometimes it helps to take a breath, let part of it out, and then hold it), and with your right thumb, actuate the Shutter button.**

 The iPhone's shutter does not operate when you press your thumb on the shutter icon. The picture is taken when you release your thumb from the shutter icon. If you press and hold your thumb on the icon until you get the image you want and then gently lift your thumb, the camera is less likely to jiggle when you take the picture.

Taking a landscape photo

What if you want to take a photo of a landscape or any scene that is wider than it is tall? Easy, just orient the iPhone horizontally. The iPhone screen will orient the view similarly. Here's how you do this:

1. **Turn your iPhone 90 degrees to the right or left.**

 Although you can turn the iPhone to the right or the left, I recommend turning it left (counter-clockwise) 90 degrees. This puts the lens and the LED flash (on the iPhone 4) above the area your hands will occupy.

2. **Place your left hand as shown in Figure 2-2.**

 Your left hand should be almost in the same position that it was in for the vertical orientation. Make sure your fingers don't cover the camera lens or flash, if you have one!

3. **Bring your right hand up and wrap it around the back of the iPhone and let your fingers overlap the fingers of your left hand. This brings your right thumb near the Shutter button.**

 Push your elbows into your body.

4. **Press and hold the Shutter button until you have the image you want onscreen.**

5. **Take a breath, let part of it out, and then gently release your thumb pressure to take the photo.**

Figure 2-2: Holding the iPhone horizontally.

In the toolbar at the bottom of the Camera app, a thumbnail of the photo you just took displays on the left. The image is now stored on the Camera Roll on your iPhone and can be viewed using the Photos app.

Understanding autofocus

If you have an iPhone 3GS, you have a camera system that can automatically adjust focus. To use the autofocus feature, do the following:

1. **Launch the Camera app on your iPhone 3GS.**

 When the camera opens, you momentarily see a box with white borders in the center of the screen where the iPhone camera is focusing (see Figure 2-3).

2. **Reposition the iPhone on a different scene.**

 When you move the iPhone, the camera shows the autofocus box for a moment and focuses on whatever is in the middle of the screen, no matter the distance. When the box disappears, your iPhone is focused, and you're ready to take your photo.

But wait a minute. What if you don't want to focus on what's in the center? No problem. Just tap any object or area in the screen that you want to focus on. The white autofocus box will appear over that object and autofocus. Figure 2-4 shows an example of off-center focusing using the iPhone 4, but the 3GS operates the same way.

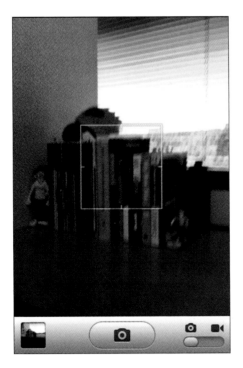

Figure 2-3: iPhone 3GS autofocus box.

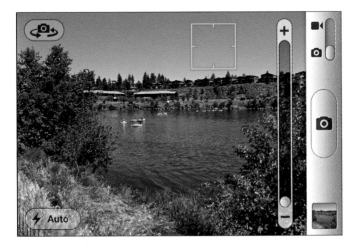

Figure 2-4: Focusing off-center with iPhone 4.

In a fix with the fixed aperture

The iPhone's camera lens has a fixed aperture (f/2.8 for the 3GS and f/2.4 for the iPhone 4), which helps in low-light situations. Any digital camera has three variables it can adjust to make a correct exposure: aperture, shutter speed, and the sensitivity of the sensor behind the lens. With a fixed aperture, the iPhone camera must automatically adjust both the sensitivity of the sensor (called the ISO, where a higher number denotes more sensitivity) and the shutter speed to take properly exposed photos. You have no direct control over either of these variables.

If you use the Camera app to take your photo, you can see the settings your iPhone camera uses (albeit after the fact) when you import a photo from a 3GS or 4 into iPhoto '09. In iPhoto, select the photo and then choose Photos⇨Show Extended Photo Info. As shown in the figure, photo information including aperture, shutter speed, and ISO displays. Although you can't change the settings, you know what settings the

iPhone 3GS or iPhone 4 camera used. This information is also available in Photoshop Elements.

Extended Photo Info	
Image	
Width:	2,592 pixels
Height:	1,936 pixels
Original Date:	6/27/2010 3:22:25
Digitized Date:	6/27/2010 3:22:25
File	
Location	
Camera	
Exposure	
Shutter:	1/1774
Aperture:	f/2.4
Max Aperture:	—
Exposure Bias:	—
Exposure:	Normal program
Exposure Index:	—
Focal Length:	3.85mm
Distance:	—
Sensing:	One-chip color area
Light Source:	—
Flash:	Off
Metering:	Spot
Brightness:	—
ISO Speed:	80

When you tap the screen for an off-center focus point, take the photo right away. If you move the iPhone any appreciable distance, the focus point will return to the center of the scene.

Without forcing you to think about it, the iPhone 3GS and iPhone 4 cameras white balance automatically. White balance, critical in making your photographs look natural, adjusts for the light you're photographing in and removes any overall color cast that otherwise would appear and ruin the shot. You've probably seen photos where there is a purple or green tone to the entire photo caused by improper white balance. The iPhone 3GS and iPhone 4 take care of this for you.

When you have the focus the way you want it, simply use the techniques in the previous section to take the photograph.

For residing in a cell phone, the iPhone camera does an amazingly good job given its small size. In Chapters 4, 5, and 6, I show you how to use your basic photography skills to help make your photos as good as they can be.

Turning your photo into wallpaper

Taking photos with your iPhone is a lot of fun. But you can do other things with your photos besides storing and sharing them. How about making one of them your iPhone wallpaper? Wallpaper is the background you see on the Slide to Unlock screen.

To turn your photos into wallpaper:

1. **Take a photo with your iPhone or open the Photos app and select a photo from the Camera Roll or one of your albums.**

 See Chapter 1 if you need more instruction.

2. **Press the action icon at the bottom of the screen (it has the curved arrow), as shown in Figure 2-5.**

3. **When the destination buttons appear, press Use as Wallpaper, as shown in Figure 2-6.**

 The Move and Scale screen appears, as shown in Figure 2-7.

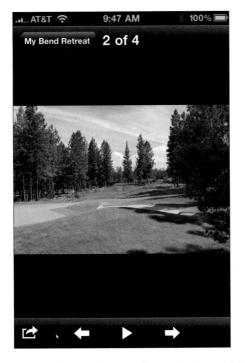

Figure 2-5: Press the action icon at the bottom left.

Figure 2-6: Your destination choices.

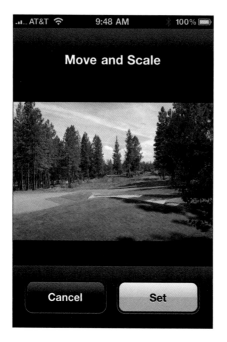

Figure 2-7: The Move and Scale screen.

4. **Use your finger to move the photo and, using standard iPhone techniques, use two fingers to pinch or zoom the photo and resize it to look the way you want.**

5. **When you're satisfied, press the Set button.**

 You can now choose which screens you wish the wallpaper to appear on: the Lock screen, the Home screen, or both. The choices are shown in Figure 2-8. For this example, I chose Set Both. The photo will be the background on the Slide to Unlock screen, as shown in Figure 2-9 and on the Home screen.

Another way to convert a photo to wallpaper involves using the Settings app and only previously taken photos. The Settings icon is on your iPhone's Home screen unless you moved it.

1. **Near the top of the Settings screen, tap the Wallpaper option outlined in red (see the left side of Figure 2-10).**

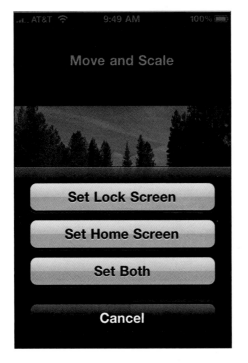

Figure 2-8: Choices of screens to wallpaper.

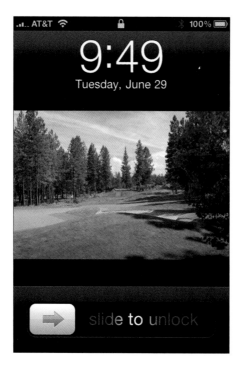

Figure 2-9: Your iPhone displays your new wallpaper.

Figure 2-10: Tap Wallpaper on the Settings screen.

On the right side of Figure 2-10, a screen appears that shows your current wallpaper settings. Tap anywhere on that image, and a screen similar to Figure 2-11 appears.

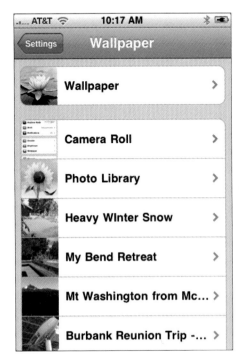

Figure 2-11: Screen for choosing standard or personal wallpaper.

2. **Tap Wallpaper at the top (see Figure 2-11) to see the images you can choose from.**

 Apple has a variety of standard wallpapers on the iPhone. The other entries shown are my photo albums.

3. **Tap the photo you want for your wallpaper image.**

 You can try several images. Just tap Cancel to try another.

4. **After you select the photo you want, tap the Set button.**

 You can also tap a photo album, or the Camera Roll, and choose a photo from there.

 For your photos you can use your finger to move the photo and use two fingers to pinch and zoom to get the look you want. The Apple-furnished images cannot be moved or resized.

Doing A Few Simple Projects

As you may have guessed, you can distribute and use your photographs many ways, including photos not taken with your iPhone. Doing projects that let you explore these possibilities will make that clear.

Syncing photos onto the iPhone

Say you're planning to visit friends and want to show them your photos from a recent event. However, the photos aren't on your iPhone, they're on your computer, and you don't want to take that with you. That's no problem as long as you have iTunes on your computer. With it you can transfer photos and videos into your iPhone's Photo Library.

The following steps use iTunes, which is available for Mac and Windows PCs. If you don't have iTunes already, you can download it from the Apple Web site at www.apple.com/itunes/download.

1. **Open iTunes and connect your iPhone to your Mac or Windows computer (see Chapter 1).**

2. **In the iTunes Source List (the left column of the iTunes window) highlight the name of your iPhone that appears under Devices, and then click the Photos tab at the far right of the iTunes window.**

 A screen similar to the one shown in Figure 2-12 appears.

Make sure this box is checked. Photos tab

Figure 2-12: iTunes window with iPhone connected.

3. **Make sure the Sync Photos From box at the top is checked and then select the source for the sync (in this case, iPhoto) from the drop-down menu.**

 You see several other choices you must make in order for iTunes to sync precisely what you want:

 - Select the All Photos, Albums, and Faces button to sync everything from your source (iPhoto, Aperture, or a folder) onto your iPhone.

 - Mark the Selected Albums, Events, and Faces, and Automatically Include radio button to pick the items you want to sync from the lists lower in the window. The drop-down menu choice that reads "no events" simply allows you to choose which events you want. You can also choose events by time spans.

 - Select the Include Videos checkbox if you wish to sync videos.

4. **For this project, click the Selected Albums, Events, and Faces, and Automatically Include button so you can choose exactly which albums, events, or faces you want to sync.**

 This ensures you don't fill up your iPhone unnecessarily.

5. **When you're satisfied with your choices, click the Apply button in the lower-right corner of the window.**

 The Apply button changes to a Sync button; iTunes backs up your iPhone and then syncs the photos, albums, or events you selected.

6. **(Optional) Check the sync's progress in the Status pane (directly below the word iTunes in Figure 2-13) at the top of the iTunes window.**

Figure 2-13: You can watch your sync's progress in the Status pane.

When iTunes finishes syncing, a message stating you can disconnect your iPhone displays in the Status pane.

7. **Click the Eject icon next to your iPhone's name in the Devices section, as shown in Figure 2-14.**

▼ DEVICES
▼ ⬛ My iPhone
🎵 Music

Figure 2-14: Click the Eject icon to safely disconnect your iPhone.

When you sync your iPhone with iTunes, the Photo Library on your iPhone adds or deletes photos based on your selections. No changes are made to your Camera Roll contents when syncing.

Creating your first slideshow

When you use your iPhone to take photographs of people or places that are significant to you, it's only natural to want to share the images with friends and family.

Of course, you can open the Photos app on your iPhone, select an album or two, and tap the Forward and Back buttons to cycle through your photographs one click at a time. If that becomes tedious, there's a much better way to show your friends a bunch of your photos. You can create a slideshow. Here's how:

1. **Go to your Home screen and tap the Settings icon.**

2. **Scroll down to the Photos entry and then tap the Photos icon.**

 The Slideshow settings screen appears, which allows you to set the slideshow parameters, as shown in Figure 2-15.

Figure 2-15: Slideshow parameters.

3. **Tap the Play Each Slide For option that lets you set the playing time for each slide.**

4. **In the Play Each Slide For screen (shown in Figure 2-16), choose the time by tapping the appropriate option.**

 In Figure 2-16, 5 seconds is selected.

.ıl. AT&T 🛜	11:51 AM	✳ 🔋

‹ Photos **Play Each Slide For**

2 Seconds

3 Seconds

5 Seconds ✓

10 Seconds

20 Seconds

Figure 2-16: Setting the duration of each slide.

5. **Tap the backward-facing Photos arrow at the top of the screen.**

 You return to the Slideshow settings screen.

6. **Tap the Transition option to set the transition type.**

 The Transition screen appears, as shown in Figure 2-17.

7. **Choose a transition by tapping its option.**

 In Figure 2-17, Cube is selected.

8. **Tap the backward-facing Photos arrow at the top of the screen.**

 From here, you have two simple On/Off choices left to make. The selections are set to Off by default.

Figure 2-17: Setting your slideshow transition.

9. **To set your slideshows to repeat until you stop them, swipe your finger to the right over the Repeat On/Off switch. The switch changes to On. To change it to Off, swipe your finger to the left.**

10. **If you want the Photos app to randomly shuffle the display order of your photos, slide the Shuffle On/Off switch to On.**

 That's all you have to do to set up a slideshow on your iPhone. Of course, you can change any of the settings at any time.

Playing a slideshow is fairly straightforward. Here's all you need to do:

1. **On your iPhone tap the Photos app icon.**

2. **Display your Albums, Events, or Places (a map showing your photo locations) by tapping the appropriate icon at the bottom of the screen.**

 See the left side of Figure 2-18. Slideshow controls are discussed in Chapter 1.

Figure 2-18: Playing your slideshow.

3. Tap the Events button and select an event.

I chose an event called Heavy Winter Snow. Tap the photo you want to begin the slideshow. I chose the first one. Then tap the Play button to start the slideshow. See the right side of Figure 2-18.

To stop the slideshow at any time, just tap your iPhone screen.

That's it. Now you can always amaze and entertain your friends.

Assigning a photo to a contact

The iPhone gives you the ability to take a photo and assign it to one of your contacts in the Contacts app. You can use a real photo of the person or something fun and offbeat, like a cartoon or a drawing. The iPhone doesn't know the difference and doesn't care.

Mac users are probably familiar with the Address Book application that contains your contacts. If you sync your Address Book contacts with your iPhone, you can view and edit contact information even when you're away from your computer.

I show you how to assign a photo to a contact in Address Book on your Mac and then transfer that contact information from your Mac to your iPhone.

1. **To add or change the photo for the contact, open the Address Book application on your Mac, select a contact name, and then select Card⇨Choose Custom Image, as shown in Figure 2-19.**

 You can also double-click the photo area to the left of the contact name and get the same result.

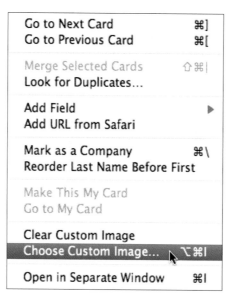

Go to Next Card	⌘]
Go to Previous Card	⌘[
Merge Selected Cards	⇧⌘∣
Look for Duplicates...	
Add Field	▶
Add URL from Safari	
Mark as a Company	⌘\
Reorder Last Name Before First	
Make This My Card	
Go to My Card	
Clear Custom Image	
Choose Custom Image...	⌥⌘∣
Open in Separate Window	⌘∣

Figure 2-19: Menu selection for changing a photo.

2. **In the drop-down dialog box that appears, you can choose an existing photo from your Mac by clicking the Choose button, as shown in Figure 2-20.**

3. **Browse to the photo, select it, and click the Open button.**

 The chosen photo displays, and you can use the slider under the photo to adjust its size.

Adjust the size with the slider

Click Choose... Set button

Figure 2-20: Choosing a photo for your contact.

4. **(Optional) Click the Effects button, which is just below the slider on the right, and choose an effect from the library.**

A number of effects are available to apply to your photo. One set is shown in Figure 2-21.

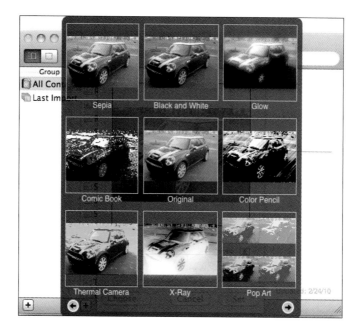

Figure 2-21: Choose from these effects.

If you change your mind and don't want to add an effect, click the Original photo in the center.

5. When you're satisfied, click the Set button (refer to Figure 2-20).

The photo is assigned to your contact page, as shown in Figure 2-22.

That's all it takes for the first part of the operation. Now I show you how to set the photo for a contact on your iPhone. As you can tell, I've used false contact information within the contact page for this example.

1. Take a photo with the Camera app or select a photo from your Camera Roll or Photo Albums.

See Chapter 1 if you need more instruction.

2. Tap the action icon (with the curved arrow) on the bottom left of the screen.

Your destination options appear, as shown in Figure 2-23.

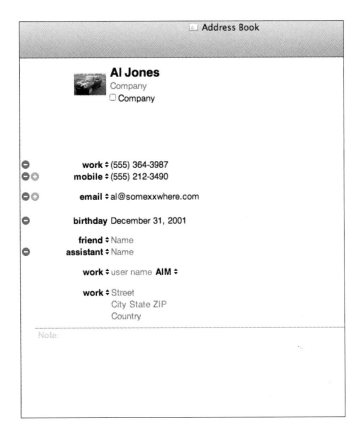

Figure 2-22: The finished contact page with the photo.

3. **Tap the Assign to Contact button.**

 Your Contacts list on your iPhone displays.

4. **Select the appropriate contact.**

 A screen similar to the one in Figure 2-24 appears, allowing you to move and scale the photo as necessary.

5. **When you're satisfied, tap the Set Photo button.**

 When you check your chosen contact's entry in Contacts, you see it has the photo you selected, as shown in Figure 2-25.

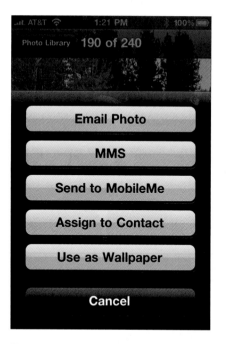

Figure 2-23: Action icon selections.

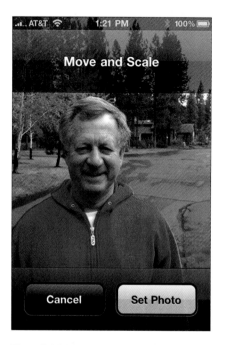

Figure 2-24: The Move and Scale screen.

.atl. AT&T 🛜 ☀ **1:23 PM** ✳ 100% ▭

◁ All Contacts **Unified Info** Edit

Al Jones

mobile	**(555) 212-3490**

work	**(555) 364-3987**

ringtone	**Default**

email	**al@somexxwhere.com**

birthday	**December 31, 2001**

Text Message	FaceTime

Figure 2-25: Your contact with the chosen photo.

Great fun isn't it? It's really easy to make your contacts much more personal.

You can set your Address Book preferences to sync your iPhone's Contacts app with your Macintosh Address Book using a MobileMe account. You can also set your Address Book preferences to sync the Address Book with your Yahoo! or Google contacts by entering your Yahoo! or Google account names and passwords in the Accounts preference.

Although you can set the photo on the iPhone, you can't choose an effect on the iPhone. To do that, Mac users have to edit the contact page in Address Book, as shown earlier in this section.

E-mailing your photos

A real joy for me is to find a scene or occurrence that, while not fine art, makes capturing a photo something special. Extra special if I can quickly share it with friends and family.

Of course, in the past, I would have to get to a computer to download pictures from my digital camera or worse, wait a few days to get the film developed and then scan the photos into the computer. By then, the spontaneity of the moment is gone. But with the iPhone, I always have a camera handy, and I can e-mail a photo right after I take it. Here's how you do it.

1. **Take a photograph with the Camera app or select a photo from your Camera Roll or Photo Albums.**

 See Chapter 1 if you need more instruction.

2. **Tap the action icon at the bottom left of the screen, as shown in Figure 2-26.**

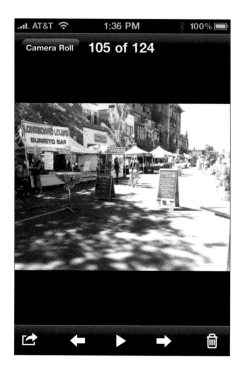

Figure 2-26: Selecting a photo to e-mail.

3. **Tap the Email Photo button shown in Figure 2-27.**

 The New Message screen appears, as shown in Figure 2-28. Here you can prepare your new message that's embedded with the photo you chose.

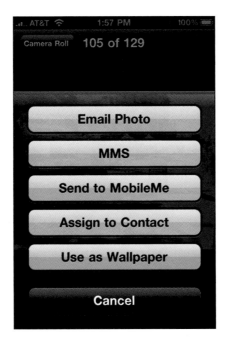

Figure 2-27: Choose Email Photo.

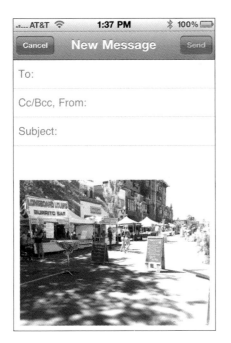

Figure 2-28: The New Message screen.

 4. **Tap the To: line and enter the address or addresses you wish.**

 Fill in the Cc/Bcc: line and enter a subject if you wish.

 5. **Add a text message and then tap the Send button.**

 Your photo is on its way.

When you send a photo via e-mail, the resolution of the photo is reduced to 800 x 600 pixels or about .5 megapixels regardless of the original resolution. (Maximum resolution depends on which iPhone model you have. For example, the 3GS has a maximum resolution of 3 megapixels, or 2048 x 1536, and the iPhone 4 has 5 megapixels, or 2592 x 1936.) If you want to send a photo at your iPhone camera's full resolution, you must make a copy of your photo and paste it into an e-mail. Here's how:

 1. **Take a photograph with the Camera app or select a photo from your Camera Roll or Photo Albums.**

 See Chapter 1 if you need more instruction.

 2. **Press and hold your finger on the photo until the Copy command appears, as shown in Figure 2-29, and then tap Copy.**

Figure 2-29: Tap the Copy command.

3. **Press the Home button on your iPhone and then tap the Mail icon.**

 The Mail icon should be at the bottom of the Home screen.

4. **Tap the New Mail icon (paper and pencil) in the bottom right of the Mail Inbox screen, as shown in Figure 2-30.**

New Mail icon

Figure 2-30: The iPhone's Mail Inbox.

5. **The New Message screen appears where you can choose an e-mail recipient and fill in the Subject field.**

6. **Press and hold your finger in the body of the e-mail until the pop-up Paste command appears, as shown in Figure 2-31.**

7. **Tap Paste, and voilà, your full-resolution photo is pasted into your e-mail. Press Send, and your masterpiece is on its way.**

The e-mail recipient can then save the enclosed photo at its full resolution.

Figure 2-31: Pasting a photo in the New Message screen.

Including photos in an MMS message

Sending your photos in an MMS (Multimedia Messaging Service) message from your iPhone 3G/3GS or iPhone 4 is very similar to sending photos in an e-mail (discussed in the previous section). Let's see how:

1. **Select the photo that you wish to send in an MMS message and tap the action icon in the bottom left of the screen.**

 See Chapter 1 if you need more instruction.

2. **On the destinations screen, tap the MMS button.**

 The New MMS screen appears, as shown in Figure 2-32. This is where you compose your message.

3. **Type your message in the area with your photo. Fill in the To: line and then tap the Send button.**

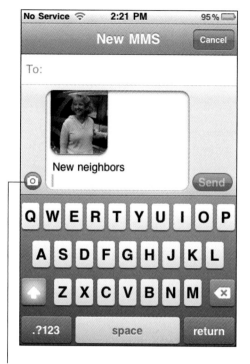

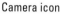
Camera icon

Figure 2-32: The New MMS message screen.

In Figure 2-32, tapping the Camera icon lets you add more photos. Here's how:

1. **To add more photos, tap the Camera icon.**

 Two choices appear: Take Photo and Choose Existing, as shown in Figure 2-33.

2a. **Tap the Take Photo button to take a new photo in the Camera application that opens.**

 The Preview screen appears (see Figure 2-34). You can examine the photo you just took and either retake the photo or use the current one.

Figure 2-33: Adding photos to your MMS message.

Figure 2-34: The Preview screen.

When you tap the Choose button, your MMS message reappears with both photos included, as shown in Figure 2-35.

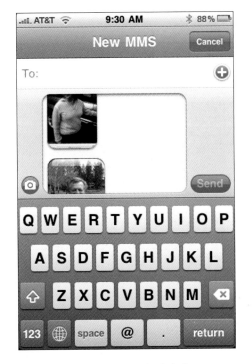

Figure 2-35: A new photo is included.

2b. Tap the Choose Existing button (refer to Figure 2-33) to use an existing photo.

The Photos application launches, and you can choose a photo from the Camera Roll or any of your Photo Albums by tapping it. Following your selection, tap the Choose button to place your existing photo in your MMS message. Tap Cancel to make another choice.

3. Tap the white space to the right of the photos and use the keyboard to add a text message.

4. When you finish, tap the Send button, and your message and photos are on their way.

Hurray, you just sent your first MMS message complete with photos. What a fun way to share with friends and family.

MMS is not available on the original iPhone.

Sending your photos to MobileMe

There's no doubt that technology makes it fairly easy for us to share photos and videos using instant messages and e-mails. But there are addresses to type and photos to attach, which take time. If you're blessed with lots of friends and a large family, keeping them up to date with what you're doing can be a serious drain on your time and pushes your typing skills on a small keyboard to the limit.

Enter MobileMe. If you don't have a MobileMe account, perhaps this task will get you interested in setting up an account. With a MobileMe account, you can upload your photo to the MobileMe Gallery, and send a message notifying your friends and family where they can go to view the photo. Here's how this works.

1. **Tap the Photos icon and choose the photo you want to share from one of your albums, Photo Library or Camera Roll by tapping the photo (see Chapter 1 if you need more instruction on doing this step).**

2. **Tap the action icon (with the curved arrow) and choose Send to MobileMe.**

 The Publish Photo screen appears, as shown in Figure 2-36. Your MobileMe account is shown at the bottom of the Publish Photo screen.

Figure 2-36: Picking your album, entering the title, and describing your photo.

3. **Select the album (at the bottom of the screen) in your MobileMe Gallery you wish to use (Museums is chosen in the example) and then tap the Title area to enter a title for the photo.**

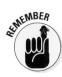

 The iPhone keyboard appears so you can enter a title (mandatory) and a description (optional). Until you enter a title, the Publish button is disabled.

 Photo albums must be set up in your MobileMe account. You cannot create them from the iPhone.

4. **When you're satisfied with the information, tap the Publish button to begin the MobileMe publishing operation.**

 When publishing completes, the choices shown in Figure 2-37 appear:

Figure 2-37: Options after publishing your photo.

- *View on MobileMe:* Tap the View on MobileMe button to see the photo on your iPhone browser, as shown in Figure 2-38.

- *Tell a Friend:* Tap the Tell a Friend button to tell friends and relatives where they can see your album. Figure 2-39 shows the message screen.

- *Close:* Tap this button to close the screen and return to your original photo.

Figure 2-38: Your photo displayed on your Web browser.

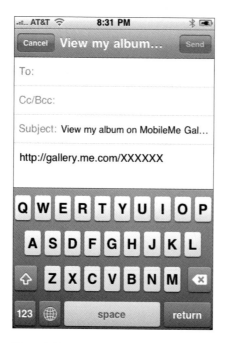

Figure 2-39: An invitation to view photos added to an existing MobileMe Gallery.

Figure 2-40 shows the album and the added photo in my MobileMe account as viewed with my Mac browser.

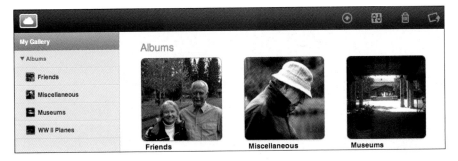

Figure 2-40: Viewing the published photo or Gallery.

Isn't this a great way to share? You can send the e-mail invitations to view your album to as many friends and family members as you wish without attaching any of the photos. Now that's efficient.

Taking Video with an iPhone

I've been in the photography business for quite some time, and I've seen and used a lot of equipment, but I'm still astounded by the quality of the video from this relatively tiny phone I can carry in my pocket. Even the audio captured by the iPhone is remarkable. And my original comment, altered slightly, that I make at the beginning of this book is still true. The best video camera is the one you have with you.

Let me show you how easy it is to use your iPhone 4 and 3GS camera for video.

Only the iPhone 4 and 3GS have video capability.

Capturing Video

One of the great things about either the iPhone 4 or iPhone 3GS video camera is that you access it with the Camera app. So when you have a photo all lined up and feel video would be better, you don't have to mess around with starting a different application. Brilliant. Here's how to capture video:

1. **Tap the Camera icon on the Home screen or the screen you moved it to.**

 Figure 3-1 shows the iPhone 4 (left) and the iPhone 3GS (right) screens. At the bottom right of the iPhone screen is a switch with two icons; one looks like a 35mm camera, and the other looks like a video camera. On the iPhone 4 image, the top-left icon is for the LED flash, and the top-right icon switches between the front and rear cameras.

For the iPhone 4, the flash can operate whether you are capturing video or a photo. Leave the flash icon set to Auto, and the iPhone 4 will do the rest.

Normally, there would be an image showing on the iPhone screen in the next two figures. I removed them so you can concentrate on the controls.

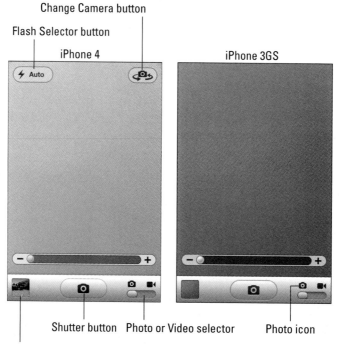

Figure 3-1: The Camera app.

2. **Swipe your finger over the switch toward the video camera icon.**

 You're now in Video mode. Figure 3-2 shows the controls on the iPhone 4 (left) and iPhone 3GS (right). The center button has changed to a red Record button.

3. **When you have the view you want, tap the Record button to start recording video.**

 The button pulsates to let you know that the iPhone is recording. While you're recording, the icon for switching cameras is hidden; therefore, you can't change cameras during recording.

4. **When you want to stop recording, tap the Record button again.**

 The video thumbnail appears at the bottom left of the screen.

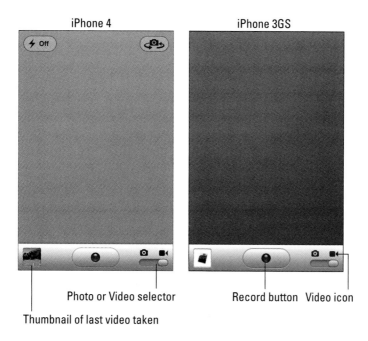

iPhone 4 iPhone 3GS

Photo or Video selector Record button Video icon

Thumbnail of last video taken

Figure 3-2: The Camera app in Video mode.

Editing Video on the iPhone

The amount of storage space you have on your iPhone 4 or 3GS determines how much video you can keep on your iPhone. For an iPhone 3GS without any other stored content (like ebooks, music, or other downloaded material), a good estimate is that nine hours of video can be stored on a 16GB iPhone. That's quite a bit of 640 x 480, 30-frames-per-second video literally at your fingertips. The iPhone 4 records at full 720p High Definition (1280 x 720 pixels) and 30 frames per second. A minute of video on iPhone 4 is approximately 80 MB. Note that the front camera takes up less storage space than the rear camera, because the front camera captures video at a lower resolution. These video files can grow in size very quickly, which makes editing mandatory. And believe it or not, you can do some rudimentary editing right on your iPhone, which helps manage your precious storage space. Later in the chapter, I show you how to use the new iMovie app on your iPhone 4 for more extensive editing. For standard editing, follow these steps:

1. **In the Camera Roll, tap your video to select it.**

 The first frame of your video appears with a Play button in the center and a strip of video frames across the top. See Figure 3-3.

2. **With your finger, press and hold either end of the strip and drag horizontally to trim or shorten the clip.**

First frame of video

Clip strip

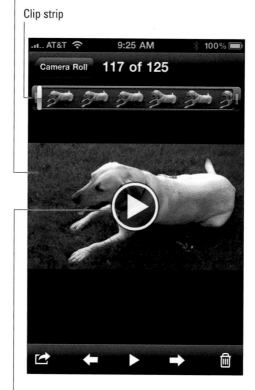

Play button

Figure 3-3: Opening screen of your video.

You can do this on either end of your video or both ends. When you begin to drag, a Trim button appears at the top right, as shown in Figure 3-4.

If you tap the Play button at the bottom, the trimmed clip plays so you can see if you have what you want or you need to adjust the trim. Tap the Cancel button to negate any changes and start over.

3. **When you're satisfied, tap the Trim button.**

The Trim dialog appears, as shown in Figure 3-5.

Trim button

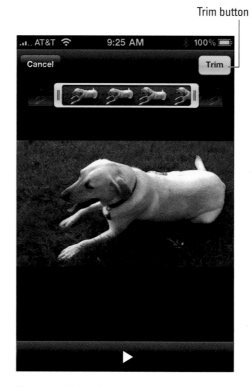

Figure 3-4: Preparing your edit.

4. **Tap Trim Original to permanently delete the frames from the original video; tap Save as New Clip to save the trimmed video in the Camera Roll on your iPhone; tap Cancel to go back and adjust the trim points again.**

When you select Save as New Clip, your original video remains untouched.

This type of editing may be all you need to do on your iPhone. It allows you to eliminate portions of the video that are extraneous or contain subjects you didn't realize were included. Trimming also cuts the size of the final video, an important consideration, especially when sending video via e-mail. For iPhone 4 owners, a more powerful editing tool, the iPhone 4 version of the Mac application iMovie, is available from the App Store for about $5. (See "Editing Video with iMovie on Your iPhone 4" later in this chapter.)

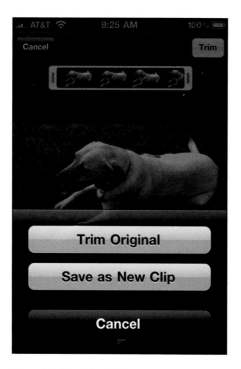

Figure 3-5: The Trim dialog.

Sharing Your iPhone Videos

When your video is shot and edited to your liking, you might want to send it to your friends and family. Luckily, sharing a video is as easy as sharing a photo. The iPhone uses the same destination icons and choices you're familiar with, as shown in Figure 3-6. Note that you don't have as many options here as you do with photos, and the high-resolution videos the iPhone 4 produces are compressed before being sent.

Sharing video via e-mail

1. **Tap a video to share from the Camera Roll, the Photo Library, or a photo album on your iPhone 3GS or iPhone 4. You can share a video at the completion of its trimming operation, too.**

 A screen similar to Figure 3-3 appears.

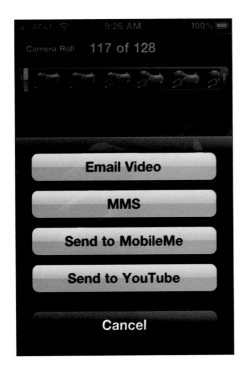

Camera Roll 117 of 128

Email Video

MMS

Send to MobileMe

Send to YouTube

Cancel

Figure 3-6: Destination choices for videos.

2. **Tap the action icon on the bottom left of the screen.**

 Your destination choices for sharing the video display (refer to Figure 3-6) appear.

3. **Tap the Email Video button to attach your video to an e-mail message.**

 The iPhone compresses the video to make it as small as possible and attaches it to a blank e-mail message, as shown in Figure 3-7.

4. **Enter an address on the To: line, enter a subject, and then tap the text area just above the video file (.mov) icon and enter any message you wish.**

5. **When you finish, tap the Send button.**

 Your video is on its way.

Attached video

New Message screen mockup:

.ıll AT&T 📶 9:27 AM ✳ 100% 🔋

Cancel **New Message** Send

To:

Cc/Bcc, From:

Subject:

IMG_0235.MOV

Sent from my iPhone

Figure 3-7: A blank e-mail message with an attachment.

Your wireless carrier and your Internet provider may limit the size of videos you can send via e-mail and MMS. Typically, videos need to be less than 10MB. Even if these restrictions don't apply to you they might apply to the recipient. It's best to keep the videos short and sweet.

Sharing video via MMS

To share a video via MMS, tap a video in the Camera Roll, the Photo Library, or a photo album on your iPhone 3GS. You can share a video at the completion of its trimming operation, too.

1. **Tap a video to share from the Camera Roll, the Photo Library, or a photo album on your iPhone 3GS or iPhone 4. You can share a video at the completion of its trimming operation, too.**

 A screen similar to Figure 3-3 appears.

2. **Tap the action icon on the bottom left of the screen.**

 Your destination choices for sharing the video display (refer to Figure 3-6).

3. **Tap the MMS button to attach your video to an MMS message.**

 The New MMS screen appears, as shown in Figure 3-8.

4. **Enter the message recipient's address on the To: line and then tap the white space under the video to enter a message.**

5. **When you finish, tap the Send button.**

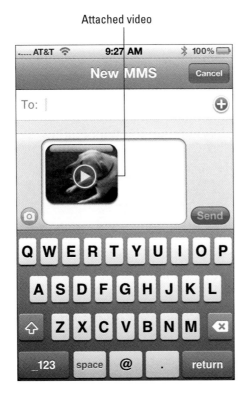

Figure 3-8: Attaching a video to an MMS message.

Sharing video on MobileMe

To share a video via MobileMe, tap a video in the Camera Roll, the Photo Library, or a photo album on your iPhone 3GS or iPhone 4. You can share a video at the completion of its trimming operation, too.

1. **Tap a video to share from the Camera Roll, the Photo Library, or a photo album on your iPhone 3GS or iPhone 4. You can share a video at the completion of its trimming operation, too.**

 A screen similar to Figure 3-3 appears.

2. **Tap the action icon on the bottom left of the screen.**

 Your destination choices for sharing the video display (refer to Figure 3-6).

3. **Tap the Send to MobileMe button (refer to Figure 3-6) to send your video to an album in your MobileMe Gallery.**

 The Publish Video screen appears, as shown in Figure 3-9.

4. **Choose an album, enter a title and description (optional), and then tap the Publish button.**

Figure 3-9: Publishing video to MobileMe.

Sharing video on YouTube

To share a video via YouTube, tap a video in the Camera Roll, the Photo Library, or a photo album on your iPhone 3GS or iPhone 4. You can share a video at the completion of its trimming operation, too.

YouTube videos can be in HD, up to 15 minutes long, and up to 2 GB in size. If you don't already have a YouTube account, go to www.youtube.com and click the Create Account link at the top of the page.

1. **Tap a video to share from the Camera Roll, the Photo Library, or a photo album on your iPhone 3GS or iPhone 4. You can share a video at the completion of its trimming operation, too.**

 A screen similar to Figure 3-3 appears.

2. **Tap the action icon on the bottom left of the screen.**

 Your destination choices for sharing the video display (refer to Figure 3-6).

3. **Tap the Send to YouTube button (refer to Figure 3-6) to publish your video on YouTube.**

 After you log in to your YouTube account, the Publish Video screen appears, as shown in Figure 3-10.

4. **Choose a category, enter a title and description, and then tap the Publish button.**

 That's it. Your video is now available on YouTube.

Figure 3-10: Publishing your video on YouTube.

Editing Video with iMovie on Your iPhone 4

Imagine yourself on vacation, enjoying the sights and sounds of the new areas you're visiting. You're happy that you didn't forget to bring the video camera — because it's in your iPhone 4! You've recorded some events and scenery that you want to share with friends and family, but you'd like to put what you've recorded into one well-structured video. Think you have to wait until you get home and edit this on your computer? Think again.

iMovie for the iPhone 4 is available to download from the App Store for $4.99. In this section, I show you how to take several videos, edit them, splice segments of each video into one video, add a theme and music, and share it with friends and family. Certainly, you'll find many more ways to use this great tool.

Setting up your iMovie project

On your iPhone 4, locate the screen that contains the iMovie icon. (For those of you with an iPhone 3GS, sorry, but the iMovie software isn't for you.)

1. **Tap the iMovie icon.**

 iMovie opens to the Projects screen, as shown in Figure 3-11.

Figure 3-11: The iMovie Projects screen.

2. **To start a new project, tap the Add (+) button in the upper-right corner.**

 A screen appears with the top half empty and the bottom half providing a way to select a theme and theme music for your project, as shown in Figure 3-12.

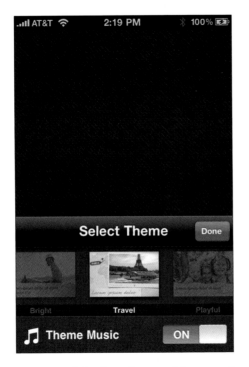

Figure 3-12: Selecting a theme and theme music.

3. **Swipe your finger left or right across the Theme thumbnails until the one you want is in the center.**

 The theme you select is illuminated. Themes include Modern, Bright, Travel, Playful and News, and you must choose one.

4. **If you want music in your project, swipe your finger on the Theme Music switch to toggle it to On.**

 A music track that is associated with the theme you chose is added to your project.

5. **After you select your theme and theme music, tap the Done button.**

 The screen shown in Figure 3-13 appears.

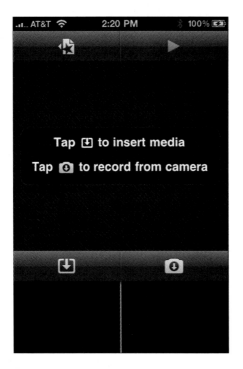

Figure 3-13: You can insert media or record from camera.

Adding and trimming your media

After you set up an iMovie project (see the previous section), you can add media and trim your video selections. After you tap the Done button in the previous steps, you see two options in the center of the screen:

- **Tap the down arrow icon to insert media:** Tapping the down arrow icon causes iMovie to display the Video contents of your Camera Roll (see Figure 3-14). Tapping the other two icons at the bottom of the screen — Photos and Audio — shows you the photos and audio on your iPhone 4 that you can also select for the project.

- **Tap the Camera icon to record from camera:** Tapping the Camera icon places your iPhone in Video mode. (I describe capturing video in Chapter 1.)

Here's how to add media to a project and trim your video selections:

1. **Tap the down arrow icon.**

 The Video contents of your Camera Roll appear.

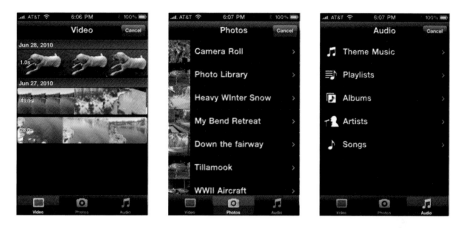

Figure 3-14: Available video, photos, and audio for your iMovie project.

2. Tap the video you want to use.

The video imports into iMovie and appears in a timeline at the bottom of the screen, as shown in Figure 3-15. The thick green line is the soundtrack, and the thin red line in the center is the "playhead," which does not move; rather, you use your finger to drag the clip right or left across the playhead.

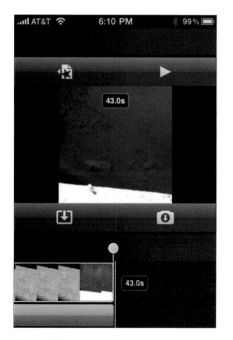

Figure 3-15: Beginning the timeline edit.

3. **To trim the clip you see at the bottom of the screen, tap it.**

 Orange trimming handles appear at both ends of the clip. Figure 3-16 shows the trimming handle at the end of the clip.

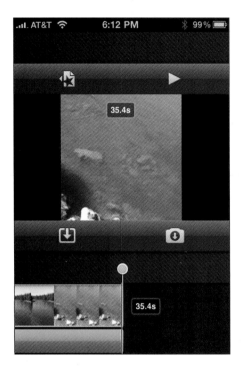

Figure 3-16: Trimming handles let you trim from either end of a video clip.

4. **Drag the beginning or ending handle to trim the clip.**

 The clip length indicator changes while you drag the handle. Clips cannot be split, however; you can only trim the beginning and end.

5. **To add a photo, an audio clip, or another video clip, tap the down arrow icon.**

 You return to the Video screen in Figure 3-14. For this example, I then tapped the Photos icon and chose a photo. The result is shown in Figure 3-17.

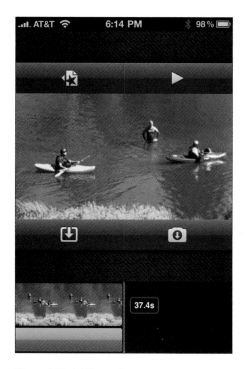

Figure 3-17: Adding a photo.

6. Tap the photo in the timeline.

The orange trimming handles appear. Moving a handle adjusts the length of time the photo displays (see Figure 3-18). Tap the Start button, and the timeline shifts to the beginning of the photo where you can adjust when it starts, as shown in Figure 3-19. Tap the End button, and the timeline shifts to the end of the photo (see Figure 3-18) where you can adjust when it stops.

7. Tap the Transition settings icon to change the transition settings between clips.

In Figure 3-19 the icon in the timeline looks like two arrows facing each other. Figure 3-20 shows the transition and timing choices available.

8. When finished, tap Done.

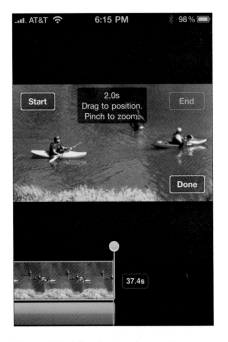

Figure 3-18: Adjusting the time a photo appears.

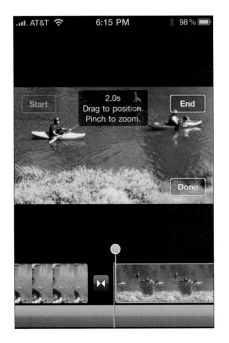

Figure 3-19: Transition settings icon.

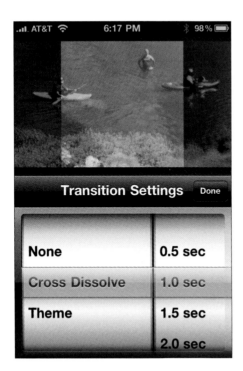

Figure 3-20: Transition Settings choices.

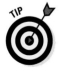

Trimming is non-destructive. You can always return to a project and drag the trimming handles to new locations.

Changing your clip settings

iMovie allows you to set the style of each clip's title and whether you want the audio on or off. (If it's just street noise or construction, you probably want it off.) Here's how you do that:

1. **In the timeline, swipe your finger to get to the clip you want.**

2. **Double-tap the clip.**

 The Clip Settings screen (left pane of Figure 3-21) appears. You can now determine the title style (center pane), enter title text (right pane), and ensure the location is correct. You can also delete the clip with the Delete Clip button.

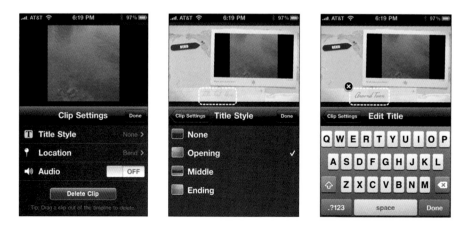

Figure 3-21: Clip Settings screen and choices.

3. **When you finish, tap the Done button.**

 Figure 3-22 shows the result for this example.

Tap when you're done

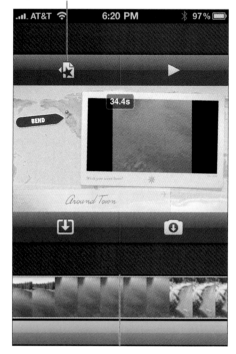

Figure 3-22: Altering clip settings.

Finishing the project

Seeing your finished product is always the nice part of any project. The last thing you have to do is to save your iMovie project. Here's how:

1. **Tap the sheet of paper with the star icon (see the upper-left corner of Figure 3-22).**

 You return to the Projects window where you started this project.

2. **In the bottom left of the Projects screen tap the action icon (this time, the curved arrow opens your export size options).**

 The pop-up shown in Figure 3-23 appears.

Figure 3-23: Choices for video size when saving.

3. **Choose the size and resolution you want to save your movie with.**

 You see an Exporting Movie progress bar while your movie saves to your Camera Roll. You cannot choose any other location.

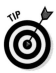

If you choose the HD size and later try to upload from your iPhone 4 to YouTube or MobileMe, your movie file will be compressed.

4. **When the save is complete, open the Photos app to see your creation (see Figure 3-24).**

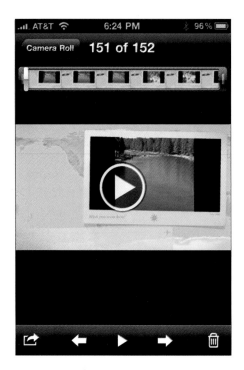

Figure 3-24: The finished project in your Camera Roll.

That's it; you're on your way to being another Cecil B. DeMille.

Part II
Making the Best Use of Your iPhone Camera

The 5th Wave · By Rich Tennant

Wait! Wait! Let me get my camera. The looks on their faces will be priceless.

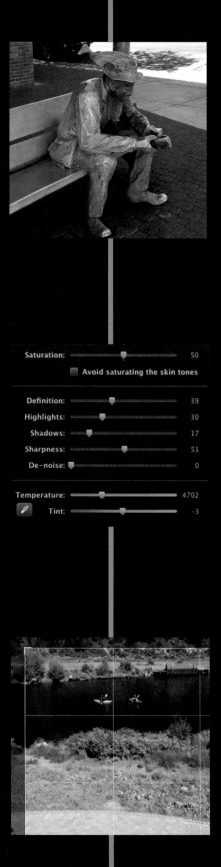

A t some time in your life, most of you have taken photographs with cameras that have varying degrees of sophistication. Typically, the more features a camera has, the more choices you have to make and the more complex the photographic process.

With the advent of smartphones everything changed. Today, you can take photographs, record video, and perform many other tasks with your iPhone. However, because of the iPhone's size and multiple personalities, your capabilities and choices are limited compared to a dedicated camera.

In Chapter 4, I help you understand the external factors that go into making a good photograph, including focus, distance from the subject, and depth of field. These factors are set at the time you capture the scene. However, you need to understand your iPhone's internal factors, too, in order to maximize the camera's capabilities. Chapter 5 takes you through these factors and what they mean.

Almost all your efforts are aimed at making your photo capture as good as it can be. But what about after you've taken the photograph? Are you stuck with whatever mistakes you made? Not necessarily. In Chapter 6, I show you the power of iPhoto '09, including how to use its histogram and powerful correction tools to make improvements to your photo.

4

Adjusting to Your Photo Environment

*Y*ou may be wondering what I mean by "your photo environment." A typical photo environment includes a variety of conditions, the most important of which is lighting. Light plays a dramatic and critical role in photography, and the main lighting environments are indoors or outside.

When you're indoors, you can change the lighting to be more favorable. Outdoors, you're pretty much at the mercy of the elements, but that doesn't mean you're completely helpless. If you take a lot of unplanned, spur-of-the-moment photos, making quick adjustments to your environment is essential to capturing a good photograph. Before you can adjust for external factors though, you have to know what to adjust and why.

Depending on which model of iPhone you have, your bag of tricks for obtaining a good photo under less-than-ideal circumstances varies. In this chapter, I show you how to take advantage of the tools you have and what you can do to make up for the tools you lack.

I also show you how to use the Rule of Thirds to enhance your photo compositions and give them more impact, whether you're at a birthday party or on a "once in a lifetime" scenic vacation. And the Rule of Thirds isn't dependant on lighting or weather; it's a powerful technique anywhere, anytime.

Understanding What Affects Your Photos

Every time you take a photograph, a number of variables affect the quality of the photo you end up with. I want to concentrate on the variables particularly relevant to the iPhone camera:

- **Type and amount of light:** Indoor or outdoor, bright sunshine or cloudy day.

 Even though we often think bright sunshine makes a perfect day, photo-graphically speaking, a cloudy day with more even lighting can be better.

- **Distance from the main subject:** Is it a close-up portrait or a landscape?

- **Movement in the scene:** Sports action, wind-blown trees, moving water, or calm day in the desert.

- **Perception of depth:** Is there an object, such as a tree or road, available in the scene to create an illusion of depth?

All these factors come into play, to some extent, in every photo you take. Some of these situations can be modified relatively easily, although the modification may involve a certain amount of work. Sure, you can modify your photos later with photo-editing software, but knowing how to get the best source shot in advance is worthwhile.

If you're the type of person who just wants to shoot a picture and move on, that's fine. Chapter 6 shows you how to improve your photographs on your computer, long after you capture them.

Lighting Is Key

Light is the key. Sounds like a no-brainer, doesn't it? Light illuminates a scene, portrays a mood or, by its absence, hides details so that our imagination fills in the blanks. You can use available light to your advantage if you understand how the camera interprets that light. "Doesn't it see what I see?" you might ask. Yes, the camera sees the same subject you see but in a different way.

Leaving technical details aside, despite all the ballyhoo about camera chips and sensors, our eyes and brains can do more. This is especially true in scenes with high contrast. Cameras have a difficult time with them, but our eyes handle them pretty well. If you're setting up to shoot a scene in the middle of the day that contains very bright and very dark areas (high contrast), your eyes adapt to that high contrast, and the scene often looks acceptable. The pitfall to avoid is thinking the camera will capture the scene the same way you see it because it won't.

Another difference between your eyes and a camera is that human vision is *binocular.* We see in three dimensions (3D) and inherently have depth

perception. A camera is *monocular* — having only one "eye," or lens — and sees in two dimensions (2D). This greatly affects the depth perception in your photos. To judge how much the effect is, make it a habit to view the scene you wish to capture with one eye closed. This approximates what the camera is seeing. Later in this chapter, I show you some ways to create an illusion of depth into your photos.

Here's an example of how lighting (in this case, natural light) can change a photograph completely. Both photos were taken with a 3GS on separate days. Figure 4-1 was taken on a very sunny day at about 1:30 in the afternoon; whereas Figure 4-2 was taken on an intermittently rainy day at about 8 in the morning.

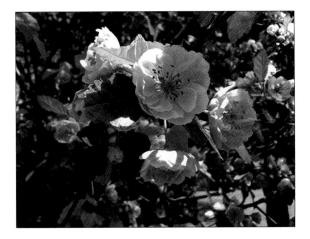

Figure 4-1: Scene with high-contrast lighting.

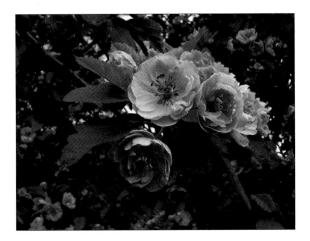

Figure 4-2: Same scene in more even light.

The details in the highlight areas of the cherry blossoms are much more noticeable in Figure 4-2. In Figure 4-1, they are burned out, and the colors in the scenes are quite different.

If you're thinking programs, such as iPhoto '09, can make lighting corrections, you're right. However, there's a limit to what they can do, and severely burned-out highlights (the brightest areas of the photo where detail is important) are probably lost forever. That's why I stress using the knowledge you gain here to make the photo capture as good as possible. Then you can use a program to make small corrections and hopefully produce a good photograph.

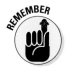

You're working with a cell phone camera, not a $1,000 camera system, so try to give your camera every chance to make a good exposure.

Here are some ideas for improving your chances of creating a photograph that's representative of the scene you see.

- **Move people into a better lighting situation:** You can't move mountains, buildings, or rivers, but you can move your human subject around. If you notice that the lighting in your scene won't work, move your subject until you find something better.

- **Move your camera to a better shooting spot:** Sometimes, the easiest thing to do is move the camera, which might also give your photo a new and perhaps better perspective. If for no other reason, I always try to view any scene from more than one position to make sure I have several options to choose from — you'd be amazed what a difference a slight change can make.

- **Wait for better light:** If your subject can't be moved or if moving your subject will destroy the composition you want, try waiting for better light. Depending on the time of year and your location, a better lighting scenario — and a better chance at capturing a great photo — might not take long.

Taking the time to understand about lighting isn't meant to destroy the spontaneity of using the small and mobile iPhone camera to capture quick shots. Understanding the environment and the workings of the camera doesn't guarantee perfection, either, but your chances of getting rewarding photographic memories increases.

Closing In on the Subject

Many of you who have experience with a standard digital camera and a selection of lenses might wonder whether lenses are available for the iPhone camera.

In Chapter 8, I show you some accessories that turn the iPhone camera into a camera with optical zoom. The accessories can be expensive, and you might not want to burden yourself with extras for which you have to find pockets! Chapter 9 discusses several applications in the Apple App Store, including the Camera app, that can provide, among other things, digital zoom capability for the iPhone camera — although the results will be lower quality than what you can obtain with an optical zoom.

Of course, there's always the tried and true method: If your photo doesn't look right, get closer to the subject. Walk, run, or drive, and fill your screen with whatever it is you're trying to capture. Nowhere is this truer than with the iPhone where the number of pixels available is small, and trying to create a reasonably-sized print by enlarging and cropping is not going to make the subject stand out any better or produce a useful print.

For example, compare Figure 4-3 to Figure 4-4. They're essentially the same shot, but in the second one, I moved closer to give better definition to the photo and also eliminate the distracting foreground.

Figure 4-3: Original shot with distracting foreground.

Figure 4-4: Getting closer makes a difference.

I certainly could have just stayed put and then cropped the shot in iPhoto, which would have looked like Figure 4-5.

The major difference between Figure 4-4 and Figure 4-5 is that Figure 4-4 uses all 3 megapixels. By cropping Figure 4-5 in iPhoto, I'm using only 2 megapixels. That's more than 30 percent less resolution and is certainly not going to enhance any print I might make. Frankly, it's worth the effort to get closer and use all the resolution of the iPhone camera.

Figure 4-5: Cropped view with fewer pixels.

Focusing on the Action

The title of this section implies two meanings. The obvious one is ensuring that the subject is placed in a way that guarantees anyone looking at the photograph knows what the central action is. The other meaning involves using auto-focus on the iPhone 3GS and iPhone 4 to focus on the subject, adjust the exposure, and enhance the capture.

I deal with the first meaning later in this chapter when I discuss the Rule of Thirds. What follows is how you can change things with a tap of the 3GS screen.

Using close-ups

Without a telephoto lens or optical zoom capability, the iPhone isn't the best choice for a landscape photo of distant objects. But up close and personal is another story. And let's face it, most of the time when you use a cell phone camera, you're capturing events that are occurring very near you.

By default, the iPhone 3GS and iPhone 4 focuses on whatever appears in the center of the camera's view and sets the exposure and white balance based on that area of the scene (see Chapter 2). Sometimes that isn't what you want and here's how you can change that.

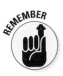

The original iPhone and the iPhone 3G do not autofocus. What you see is what you get. The lens in those cameras is able to keep almost everything in focus without adjustment. The advantage of autofocus on the iPhone 4 and 3GS is that you can focus on close objects while making distant objects fuzzy and less distracting in your composition.

1. **On your iPhone 4 or 3GS, open the Camera app and aim the camera at the subject.**

 See Chapter 1 for help with the iPhone interface.

2. **Compose the shot the way you want it to look.**

 For a few seconds, the white focusing square appears in the center of the screen.

3. **(Optional) To focus somewhere other than the center, tap an object or area of the screen you want to focus on and the camera sets the exposure and the white balance automatically.**

 If you tap somewhere and still don't like what you see onscreen, tap another object or adjacent area. When you find the choice you like, you're ready to capture the photo.

 Figure 4-6 shows a scene where I tapped in the area of the sky in the background. This lowers the exposure the camera used (because the sky is bright) giving the photo deeper colors and a darker look. If you prefer something different, you can either tap somewhere else to get a better overall exposure setting or fix the exposure in iPhoto '09 after the fact.

4. **Once you have the focus and exposure the way you want it, press and release the Shutter button to take the photo.**

 Figure 4-7 shows the same scene, in the same light, but this time I tapped on the foliage in the foreground to set focus, exposure, and white balance. Note that the scene is much lighter (because the foliage is dark). This is not to say one is correct over the other; it's to show you what happens when you focus in light or dark areas of the scene.

Figure 4-6: Focus and exposure setting for the background.

Figure 4-7: Focus and exposure setting for the foreground.

Because of the iPhone 4 and 3GS camera dynamics, sometimes exposure changes are obvious when you look at the screen (the scene gets brighter or darker) but focus changes are not. Focus changes are much more dramatic when you're doing close-up photography, say at four or five inches from the subject. Figure 4-8 shows a close-up where the camera is approximately four inches from the subjects. The autofocus system in the iPhone 4 and 3GS cameras take 1–2 seconds to do its job. I deliberately captured the photo very quickly (about ½ second) without letting the iPhone 4 and 3GS autofocus on the scene so you can see that without autofocusing. I'm too close to the object to get a proper photo. I did this for demonstration purposes only — don't try this at home.

Figure 4-8: Improper focus at a distance of four inches.

Look at the words *London Bridge;* you can see that the camera didn't focus properly for this distance.

Figure 4-9 shows the difference focus makes. This time, I let the iPhone 3GS autofocus on the scene, and the words on the stone are quite clear.

Correcting the scene for white balance

The iPhone 4 and 3GS cameras makes exposure corrections automatically by varying shutter speed, white balance, and ISO (which is a measure of the sensitivity of your digital sensor). Don't panic, I'm not going to get technical on you, at least not very much, but I think it's important to understand what these cameras are doing.

White balance is a process that makes sure the colors in your photo are correct even if the lighting that exists when you take the shot is less than perfect.

For instance, if you take a photo in bright sunlight, the colors should look natural because the available light is spread across the entire visible light spectrum. Light bulbs, fluorescent light, and other types of artificial light have a limited range of colors and can give your photo a color cast.

Figure 4-9: Proper focus at a distance of four inches.

Your eyes are quite adept at compensating for poor or improper lighting. Unfortunately, the camera isn't. Trust your viewfinder, not your eyes.

When the white balance is changed, the camera can handle the imperfect light and make the photo look good.

The sensor in a digital camera sees everything in black and white. To capture color information, a layer of red, green, and blue filters (a Bayer filter) is placed over the sensor. That's why it's so easy to turn a color digital photo into a black and white photo in photo-editing software, such as iPhoto '09. You just turn off the color information. Very complex procedures and mathematics take the individual bits of color information and create a color image. If the filter gets incorrect information because of imperfect lighting, the color image you see will also be incorrect. Doing a white balance allows the procedures to make the appropriate color corrections.

The beauty of the iPhone 4 and 3GS is that white balancing is done automatically by the camera. All you have to do is:

1. **Tap the Camera icon on your iPhone 4 or 3GS screen to launch the Camera app.**

2. Aim the iPhone 4 or 3GS toward the scene you want to capture.

Whenever you see the white square that, by default, appears in the center of the screen, such as in Figure 4-10, focus, exposure, and white balance are being calculated based on the scene contained within the square. This is where you can, optionally, exert creative control.

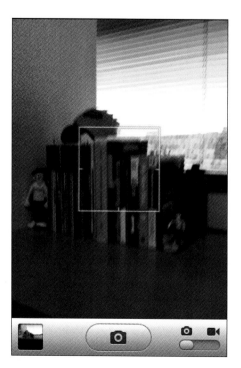

Figure 4-10: iPhone 3GS's focusing, exposure and white balance square.

3. (Optional) To change the area the white square is adjusting for, tap another part of the screen.

You see the white square move to that location and now focus, exposure, and white balance calculate based on that part of the screen.

You may see very dramatic changes in exposure and white balance when you tap different areas of the scene; perhaps more dramatic changes than you intended. Pay attention to what you see on the iPhone screen before you capture the photo.

Until you get comfortable with making this adjustment, you might tap the screen in several places before you find the balance you like.

4. When you're satisfied, tap the Shutter button to take the photo.

By using this process, you gain a greater understanding of how to control the factors that affect your photos.

Placing the subject — The Rule of Thirds

Although most composition errors in your photos can be corrected with photo-editing software after the fact, I recommend that you minimize errors before you tap the Shutter button by being aware of some simple facts.

- **Make the subject the most prominent object in the scene.** This may mean doing a little walking to get closer and put distracting elements outside the view of the lens.

- **Be careful not to fill the screen with elements that tend to pull the viewer's eyes away from the subject.** The eyes are naturally attracted to brightness, and if you have a bright object near the boundary of a photo, the viewer's eyes will tend to gravitate there. If that object isn't the subject, this is a bad thing. Getting this right takes practice. Discerning what you want the photo to say is not an exact science. It's still art, so use your judgment.

- **The Rule of Thirds can make your photo compositions more powerful.** Imagine the scene you're photographing is divided into thirds, vertically and horizontally. The rule, simply stated, is to place the key subject at or near one of the intersections, or *power points,* to give your photo a more dramatic impact and make it more interesting. Typically, placing the main subject directly in the middle is boring — avoid if at all possible. The bush in the middle of the McKenzie River (see Figure 4-11) is very near a power point and gives a pleasing composition.

 Placing a scene's horizon line along the horizontal middle of the photo is tempting. For a better composition, however, move the camera so the horizon is placed on or near one of the two horizontal lines in the grid.

Although the standard iPhone Camera application doesn't have a grid feature, in Chapter 8, I show you some photo applications you can get in the App Store that do give you the option of placing a Rule of Thirds grid on your iPhone screen. Eventually, this approach will become second nature regardless of whether a grid is on your screen.

Figure 4-11: Using the Rule of Thirds.

Capturing photos in low light

What about those times when you are indoors with friends or family or at an event in late afternoon or evening? Can you take photos under these conditions? Yes, you can but, depending on the iPhone you have, the results may be less than pleasing.

In Chapter 5, I cover some ways the iPhone camera adapts to less-than-ideal lighting conditions, namely, leaving the shutter open longer to admit more light and raising the ISO (a number that signifies the sensitivity of the camera's sensor.

If you're fortunate enough to have an iPhone 4, you have some extra tools:

- **A larger lens aperture:** This f/2.4 aperture admits more light than the lens of an iPhone 3GS. This can be of great benefit because, sometimes, you're trying to capture a certain mood in a low-light situation and you don't want to use a flash. The iPhone 4 can help here.

- **A rear-facing camera flash:** As you might imagine, the flash is fairly small and does its best job when the subject of the photograph is within a few feet of the camera (6–8 feet might be workable). If the subject is a person or an animal, red-eye can be a problem. I'm sure you've seen the devilish look this can impart to a photo. You probably won't be able to avoid red-eye, so in Chapter 6, I show you how to correct it quickly and easily in iPhoto '09.

The iPhone 4 has only one flash mode control, as shown in Figure 4-12.

Figure 4-12: Camera app screen showing the flash control.

Operating the flash control is very simple:

1. **After opening the Camera app, tap the flash icon in the upper-left corner of the screen.**

 This extends the icon and shows the three flash modes.

2. **Tap Off to prevent the flash from operating.**

3. **Tap Auto to let the camera system decide when flash is necessary.**

 This is the default setting on the iPhone 4.

4. **Tap On to have the flash fire for every photograph taken.**

That's all it takes. If you want to capture the candlelight dinner scene, just turn the flash off and see how the photo looks. You can always take the photo again with the flash set to Auto if it didn't work out.

Getting Comfortable with Depth of Field

An elementary but accurate definition of *depth of field* is that it describes the area in your photograph, from closest to the camera to farthest away, that looks in focus to the eye. Notice I said "looks in focus to the eye" because truth be told, a camera lens can only focus at one distance. However, the human eye cannot detect a lack of focus over a certain area, so we say the photo is in focus within the depth of field. This "acceptable" focus is based on viewing an 8 x 10 print from a one-foot viewing distance. So when you're viewing your photos on an iPhone screen, sharpness may look better than it is.

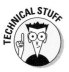

This all relates to something called the Circle of Confusion (in this case, I don't mean Congress!). Put in very basic terms, the Circle of Confusion defines how much blurring can occur before the eye rebels and says something is unsharp.

Two settings affect the size of the Circle of Confusion (thus the depth of field) for each photo we take:

- **The focus distance of the camera lens to the subject affects the sharpness of the image.** Unless you're standing on the edge of a cliff or some other impediment, you can change this variable by moving closer to the subject or farther away.

- **The aperture setting, which determines how large the lens opening is, affects how much light enters the lens.** For the iPhone 3GS, this is fixed at f/2.8 (the iPhone 4 is f/2.4), so there is no adjustment you can make. The f-number varies inversely with the size of the lens opening, so f/2.8 is a large opening while f/22 is a small one.

With the fixed aperture setting of the iPhone 4 and 3GS cameras and the construction of the lens, a focusing distance of more than three to four feet yields a *distance of acceptable sharpness* equal to infinity (∞). In other words, at that distance, about the only thing that can affect the sharpness of your photo is how still you hold the camera.

Grasping how depth of field (DOF) works

You need to know some basic facts about depth of field that allow you to use DOF to your advantage in your photo compositions. For instance, instead of keeping sharp focus everywhere, you can gain added emphasis about the photo's subject by putting its surroundings out of focus.

Table 4-1 shows a few approximate values for the close and far distances of acceptable sharpness for the iPhone 4 and 3GS. You can see that with a focus distance of four feet or more, everything will be in focus to the horizon. Conversely, if the subject is four inches away, only objects from 3.5 to 4.5 inches away will be in sharp focus.

Table 4-1	Distance Values	
Focus Distance to Subject (inches)	*Near Focus Point (inches)*	*Far Focus Point (inches)*
4	3.5	4.5
8	6.5	10
12	9	18
18	12	34
48 and greater	19	∞

Figure 4-13 is an example of a focusing distance (on the buffalo) of four inches. The rock, another three inches away, is already out of focus. This shows that with the iPhone 4 and 3GS, the closer you are to your subject, the more shallow the depth of field. You can use this lens property to your advantage in your compositions.

Figure 4-13: Example of shallow depth of field.

If you want to learn more about depth of field, I recommend starting with the tutorial at `www.cambridgeincolour.com/tutorials/depth-of-field.htm`.

Using composition to create the illusion of depth in your photos

I mention earlier in this chapter that humans see in three dimensions (3D) and inherently have depth perception; whereas, the camera, with only one "eye" or lens, sees in two dimensions (2D). That means a scene that looks good to your eyes might result in a photo with no apparent depth. What can you do about that?

If you're taking a portrait, you may not be interested in creating depth; the photo's all about the person posing. If beautiful scenery really inspires you, you undoubtedly want to capture the scene's grandeur so that viewers are equally excited.

If you're having trouble establishing depth in your photos, you can try a creative solution called *framing*. Framing is a technique that uses objects within the photograph to act as a frame or border and focuses the viewer's attention to the main subject. Framing can also provide the illusion of depth. Here are some examples on how to apply it.

> ✒ **Include something in the foreground that will at least partially frame the main subject of the photo and provide depth.**

> ✒ **Make sure the depth of field is sufficient so the foreground objects are sharp (unless, for a more artistic touch you want the foreground slightly out of focus).**

Trees, rocks, or buildings are often available and work well for framing. You might have to reposition your camera angle, but getting them in the scene will be worth it.

Figure 4-14 shows a scene partially framed by the trees, rocks, and bushes in the foreground. The natural curve of the river and surrounding roads provide complementary shapes that guide the viewer's eyes into the photo.

Figure 4-14: Using foreground objects and background shapes for depth.

Figure 4-15 shows another way to use shapes to provide the illusion of depth and lead the viewer's eyes where you want them to look. Notice how the trees and highway seem to pull you into the scene. Even the snow on each side of the highway points at Mt. Bachelor (which is a volcano by the way).

Figure 4-15: Using shapes to enhance the depth in the photo.

The beauty of iPhone digital photography is that if you don't like the photo, you can delete it and try again. Digital shots don't cost anything so don't be afraid to take lots of them.

5

Working within the Camera's Capabilities

The iPhone does a great job simplifying taking a photo. There's very little to do besides see, point, and shoot. Many common adjustments are made by the iPhone automatically and don't require your intervention. However, that means you don't have much control over certain aspects of your iPhone camera's operation that you might want to change. But you're not helpless.

Understanding what these camera adjustments are based on and what they correct is extremely important. That way, you can put yourself into photographic situations that allow the camera to perform at its maximum efficiency.

In this chapter, I show you how external factors and internal (to the iPhone camera) factors can affect the quality of your photographs.

Understanding the Effect of Fixed Aperture and Variable Shutter Speed

Traditional digital cameras (or film cameras for that matter) allow the photographer or built-in software to control the amount of light reaching the sensor or film by changing the aperture size and/or the shutter speed.

The iPhone 3GS's fixed aperture of f/2.8 (f/2.4 for the iPhone 4) allows the maximum amount of light through the lens and onto the sensor.

The "f-stop number" is inversely proportional to the size of the lens opening; the smaller the number (f/2.8) the larger the opening.

This large aperture helps in low-light situations but makes dealing with bright light tricky. To accommodate a variety of lighting situations, the iPhone can, internally, change two variables:

- **The shutter speed, which is how long the shutter is open and allowing light to reach the sensor.** Finding absolute range of speeds is difficult, but I've seen the iPhone 3GS shutter speed vary between 1/10 of a second and approximately 1/2000 of a second. Because the shutter speed is being changed by the hardware and software in the camera, you can get strange-looking shutter speeds like 1/405 so don't be surprised!

- **The ISO rating, which essentially modifies the sensitivity of the sensor.** ISO is discussed later in this chapter.

If you're using an iPhone 3GS or iPhone 4 and selectively focus by tapping on part of the screen (Chapter 4 shows you how this works), the shutter speed and ISO might change dramatically depending on where you tap your finger. Figure 5-1 shows the shutter speed and the photo focused on the shadows. Figure 5-2 shows the same thing when focused on the highlights.

Figure 5-1: Shutter speed of 1/405 when focused on the shadows in the scene.

The photo that concentrates on the highlights has a shutter speed more than twice as fast. The camera and software have adjusted the shutter speed, based on where you focused the shot, to give you a correctly exposed photo. Unfortunately, the well-defined shadows are in one photograph (Figure 5-1), and the detailed highlights are in the other (Figure 5-2)! You really want them in the same photo don't you? Of course; and how to achieve that is the topic of the next section.

Camera	
Maker:	Apple
Model:	iPhone 3GS
Software:	3.1.3
Exposure	
Shutter:	1/985
Aperture:	f/2.8
Max Aperture:	—
Exposure Bias:	—

Figure 5-2: Shutter speed of 1/985 when focused on the highlights in the scene.

Only the iPhone 3GS and iPhone 4 allow you to selectively focus. If you have an iPhone or iPhone 3G, you must use iPhoto '09 (or some other editing software) to correct your photograph. Chapter 6 shows how to do this. You may need to wait for better lighting or change your composition to prevent highlights from being blown out completely — they can't be corrected! Check your iPhone's screen; if the highlights have no visible detail onscreen, you need to make changes.

Using High Dynamic Range (HDR) Software

One of the things you learn very early in your photographic endeavors is that your eyes can handle scenes with a lot of contrast (very bright and very dark areas) easier than any camera. Your eyes simply adjust better.

For those with an iPhone 4 running iOS 4.1, there's some extra magic that the Camera app can perform. It automatically captures photos exposed for shadows and highlights with one tap of the Shutter button and merges them into a single photo that preserves both the shadow and highlight detail. You can also save the original non-HDR photo to your Camera Roll.

Your part in this is relatively easy.

1. **To save the original photo too, tap the Settings icon. Then tap the Photos entry and swipe the Keep Normal Photo button to On.**

2. **Compose the scene on the iPhone 4 screen as you would normally.**

 Holding the camera still will enhance the final photo's sharpness. Unless you have steady hands, see Chapter 7 for some ways to stabilize your iPhone.

3. **Make sure that the HDR button at the top of your screen says "On." If it doesn't, tap the button once.**

4. **Take the photo by tapping the Shutter button. Amazingly, the two photos seem to be taken as quickly as one.**

 You see a message on the screen saying "Saving HDR." The resulting Normal and HDR photos (see Figure 5-3) are saved to your Camera Roll.

In Chapter 9, I show you how to use Pro HDR, an application that runs on the iPhone 3GS and iPhone 4. Pro HDR does all the processing and has a few additional capabilities.

You can also use Photoshop to achieve these results. Playing with Photoshop is beyond the scope of this book, but basically, in Photoshop, you open the two photos and run an available script to produce the finished product.

For example, Figures 5-1 and 5-2 were shot to properly expose the shadows and highlights respectively. You can use those and Photoshop's Merge to HDR script to produce a high dynamic range photograph.

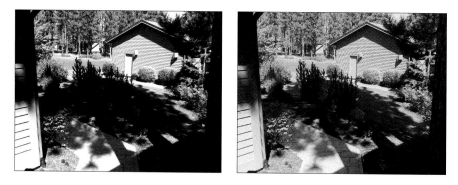

Figure 5-3: Normal and HDR photographs.

All these processes are easy ways to enhance the innate abilities of the iPhone 3GS or iPhone 4 camera in very high contrast situations. I'm sure you'll find lots of opportunities to use them in your own photo-taking experiences.

Understanding ISO

Remember that the iPhone can modify two variables in order to correctly capture a scene: shutter speed (described previously) and ISO.

The ISO number is a measure of sensitivity to light for both digital sensors and film. The higher the number, the greater the sensitivity and the better the camera handles low-light situations. Okay, just crank up the ISO and the camera can see in the dark, huh? Not so fast.

For every upside there always seems to be a downside or a price to pay. With film, when the ISO is high, the graininess of the film is quite pronounced. Sometimes, in order to get a photo, you pay the price but at least you know the grain is there.

For digital, things are a little different. "Graininess is *noise.* You may have seen it at times and not realized it. Digital noise usually manifests itself as a kind of color speckling in the shadow areas of your photo that looks like someone is sprinkling confetti in front of the camera. The higher the ISO, the more noise you get.

The culprit is the ISO speed the camera has to use, often 1000 or more. For comparison, the photos in this chapter have an ISO of 70! For low-light situations the camera will lower the shutter speed as far as possible, making the exposure as long as possible to try and get enough light. When the camera hardware and software can't slow the shutter any further, the only option is to raise the ISO high enough to get sufficient light.

Why would you ever want to do this? Well, some possibilities where low light can be a problem are

- **Indoor sports events**
- **Art galleries where flash typically isn't allowed**
- **Concerts**
- **Indoor parties**

The iPhone 4 or 3GS always tries to change the shutter speed first while keeping a low ISO to make the proper exposure. Raising the ISO is a last resort. If you have an iPhone 4, using flash is also a possibility if it's allowed.

Depending on where you are and what amount of light you have to work with, noise may become very noticeable. Computer application programs, such as Noise Ninja, can eliminate noise after the fact, but they often tend to soften the look of the photograph.

To take a photo of a moving object (athletes, animals, cars) you need the shutter speed to be fast, usually at least 1/250 of a second (faster is even better). On the iPhone, you don't have direct control of this, but because the iPhone adjusts shutter speed first, the brighter the light in the scene, the faster the shutter. With the iPhone 3GS and iPhone 4 you can also use focusing and depth of field to get what you want.

My advice is to shoot the photo and deal with the noise. If it's there, it isn't always noticeable, and you get the picture you thought was memorable enough to click the shutter.

6

Using iPhoto '09 to Enhance Your Photos

*A*fter you've done the best you can to optimize the use of available light and selectively focus to enhance the photo's composition, you might think, "Just take the picture, and you're done." Actually, you've just begun, and if you want to further enhance your photos, several software packages can help you. Covering them all in this book is impossible, so I concentrate on iPhoto '09, which comes with every new Mac or can be purchased separately.

To effectively use the power of the editing techniques available in iPhoto '09, you need to understand the type of editing you must do and how to do it.

This chapter introduces you to histograms and how to interpret what they mean for your photographs. Reading a histogram helps you correct photo problems, such as exposure and lighting, and guides you toward taking better photos. Often, capturing a scene is so immediate that you whip out your iPhone and snap a picture without thinking about composition. This chapter covers iPhoto correction tools that might help you clean up those hurried shots.

Detailed descriptions of the interplay of light, sensors, and electronics can easily become complex, so I keep things as simple as possible in this chapter. For more on how to use iPhoto to edit your photos, I recommend my book *iPhoto '09 For Dummies.* And even if you don't plan to use iPhoto, the techniques you see in this chapter transfer quite easily to other photo-editing software.

Changing the Composition after Taking Your Photo

In Chapter 4, I introduce techniques that maximize the use of your photographic environment to produce interesting and rewarding photographs. Things like the Rule of Thirds and focusing on the subject are proven ways to improve your photos when you have the time to set up your shot the way you want.

Sometimes though, you must choose speed over deliberation. Either you take the shot immediately or you won't get it at all. I can tell you from experience that if you continually practice the compositional techniques in this book, when you're forced to shoot quickly, you're more likely to orient the scene's composition in a pleasing way.

But don't worry if your shot doesn't turn out quite the way you hoped. That's where iPhoto '09 comes to the rescue.

iPhoto '09 is a Mac-only program used for post-capture editing on your Mac desktop computer. For Windows users, a program such as Photoshop Elements provides much of the same capability. The editing techniques discussed in this chapter will be invaluable regardless of the platform you use.

To help you with the discussion of iPhoto, Figure 6-1 provides a convenient guide to the iPhoto '09 interface.

The editing operations I discuss are listed in the order you should normally use when editing any photograph. It's best, for instance, to straighten and crop a photo before undertaking any exposure adjustments. You then use the histogram to make informed choices for further photo adjustments.

Editing a photo in the iPhoto Library changes it in every album, slideshow, book, calendar, or card where it appears. This is true for every Adjust tool control and the Effects tool. If you want to edit a photo without changing it elsewhere, make a duplicate of the photo by choosing Photos⇨Duplicate; then, and only then, edit the duplicate, which will have the same name as the original photo with the addition of the word "copy."

Straightening

An easy thing to do when taking a photo, especially if you're in a hurry, is to hold the iPhone at a slight angle, which means the photo will be crooked. Figure 6-2 shows a scene that is not quite horizontally straight.

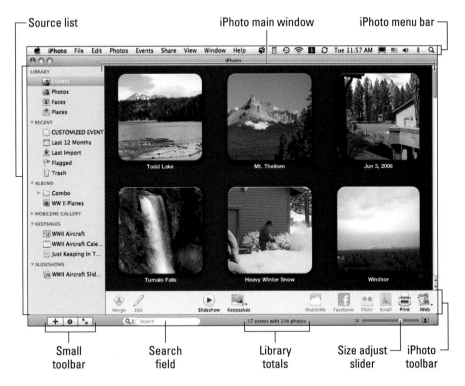

Figure 6-1: The iPhoto '09 interface.

The Rotate tool at the bottom of the Edit window changes the horizontal orientation in 90° increments each time you click it — not exactly what Figure 6-2 needs. The Straighten tool adjusts the photo in much smaller increments. For the majority of photographs, this is enough. To rotate a photo by 10° or less in either direction, follow these steps:

1. **In iPhoto, find the photo you want to work on and either double-click it or highlight the photo and click the Edit button on the iPhoto Toolbar (refer to Figure 6-1).**

2. **Press the Straighten button on the toolbar at the bottom of the Edit pane.**

 The yellow grid lines, shown in Figure 6-2, help determine the direction and extent of any necessary corrections.

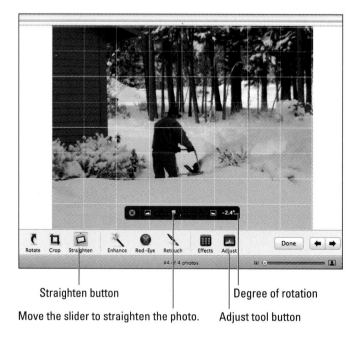

Straighten button

Degree of rotation

Move the slider to straighten the photo. Adjust tool button

Figure 6-2: Correcting a photo with the Straighten tool.

3. **Move the slider to the left to tilt the left side of the image down, or to the right to tilt the right side of the image down.**

 The applied rotation in degrees displays to the right of the slider.

4. **When the photo is straight, press Done.**

Now, take a good look at the composition of the shot. Here's your chance to take the time to make corrections you may not originally have had time for.

Cropping

Cropping is an editing feature in which your choices, your intuition, and your artistic skills can really make a difference. People are sometimes hesitant to cut anything from a photo, but I assure you, cropping often improves a mediocre photo. Sometimes less is more.

Before you actually begin cropping, I recommend you spend a few minutes just looking at the photograph in question. Ask yourself:

- What was it about the scene that interested me enough to take this shot?

- What's the subject and does it stand out?

- Are there any distractions that take the focus away from the subject?

The answers to these questions help you make the most of the photo you're cropping. After you have some practice cropping, you'll be amazed by how many creative errors you can correct in iPhoto.

The photo I chose for this example interested me yet had to be taken quickly, before the kayaks moved out of range. But it's bad enough, from a composition perspective, to require some help from iPhoto.

In Figure 6-3, you see the photograph prior to editing. What grabbed my interest was the beauty of the river, the colorful kayaks, and the high desert vegetation. The main subjects are the boats, although you might not know it from the current composition. The distractions are numerous, starting with the wide and light-colored walkway in the foreground, part of a person's leg, and a large, obtrusive object on the other side of the river. Wow, there's a lot to do.

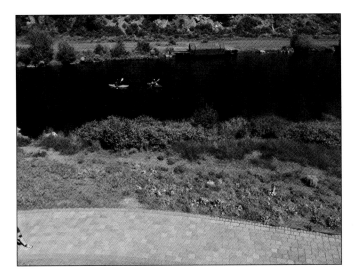

Figure 6-3: An unedited photo in need of cropping.

1. **In iPhoto, find the photo you want to work on and either double-click it or highlight the photo and click the Edit button on the iPhoto Toolbar (refer to Figure 6-1).**

2. **Click the Crop button on the toolbar at the bottom of the Edit pane.**

 The white rectangle indicates where the crop will occur. With this moveable boundary, you can adjust either manually or by selecting a size from the Constrain pop-up menu that appears, as shown in Figure 6-4. In this example, I cropped manually.

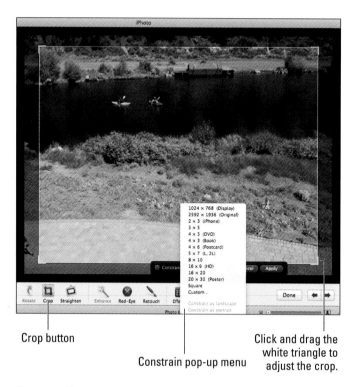

Crop button

Constrain pop-up menu

Click and drag the
white triangle to
adjust the crop.

Figure 6-4: You can use the menu to adjust crop size.

3. Hover the mouse on one of the white lines you want to adjust until the cursor changes to a line with two arrows and then click and drag the line to where you want it to go.

In Chapter 4, I mention the Rule of Thirds. Notice that when you begin to move the white line, a Rule of Thirds grid superimposes on the photo (see Figure 6-5) to help you crop and place objects.

4. Repeat Step 3 on each of the crop lines you want to move.

You can go back and move lines as often as you want until you're satisfied.

5. When you have the lines set, click the Apply button to set the crop.

Figure 6-6 shows the change I made. Still not the greatest photo, but it's certainly an improvement and captures more of the look I wanted.

Press the Shift key to compare the original photo to the cropped photo.

After you save your changes, you can revert to the original photo and start again by choosing Photos➪Revert to Original.

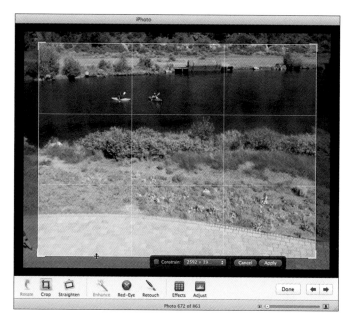

Figure 6-5: Showing the Rule of Thirds grid.

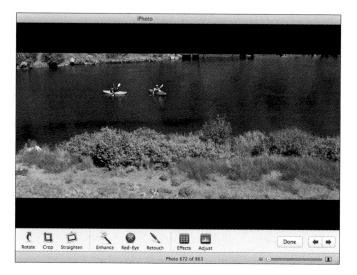

Figure 6-6: The cropped photo.

6. Click the Done button on the toolbar at the bottom of the Edit pane to exit Edit mode.

Cropping is a real art, and it can turn a photo with correctable flaws into a pleasing composition. It's certainly better than driving 100 miles or more to retake the shot! Straightening and cropping are important steps, but you can do much more, and there's something called a histogram that can help you.

Removing red-eye

Although not really a composition problem, I'm sure you've seen horrible examples of people with devilish red eyes caused by taking flash pictures in a dark area when the pupils are naturally dilated. Until the debut of the iPhone 4, this was not a problem because the iPhones had no flash. That has changed. Using the iPhone 4's flash can create red-eye problems. Luckily, iPhoto can significantly reduce red-eye with the use of a very simple tool. You should note that it only works on human eyes.

If your photo shows the effects of red-eye:

1. Open iPhoto '09, select the photo you want to edit, and then open the Edit window by double-clicking the photo or clicking the Edit button.

2. Zoom in to the area around the eyes using the size slider in the lower-right corner of the Edit window.

In order to make this work properly, you should enlarge the eyes in the photo so your adjustments are accurate.

3. Click the Red-Eye button in the Edit window.

At the bottom of the screen, you see the red-eye correction tools. (Figure 6-7 shows this with the correcting cursor just below the person's eye.) If you click the Auto button, iPhoto automatically recognizes where the red-eye problem is and corrects it. If you prefer to do the correction manually, you can adjust the size of the correcting cursor with the size slider (I show you how in the next step) or by clicking the left and right bracket keys to decrease or increase the size of the cursor (these keys are next to the P key.

I find fixing red-eye manually to be much more accurate. It can be done with just two clicks of the mouse, and I recommend doing corrections yourself.

4. To correct red-eye manually, position the suitably-sized pointer over one of the pupils to correct and then click the mouse.

Repeat this for the other eye. Figure 6-8 shows the corrected photo.

Figure 6-7: Red-Eye Tool choices and correcting cursor.

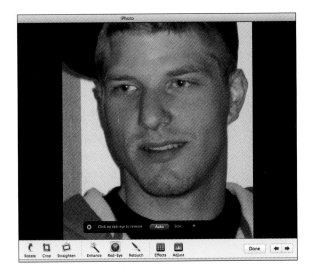

Figure 6-8: Photo with red-eye correction completed.

5. **Do this for any other subjects with the same problem. When finished, click the Red-Eye button again to turn off the tool.**

As always, you can press the Shift key to see the original photo for comparison.

6. **Click the Done button in the Edit window to exit editing mode.**

This should make whoever was the subject of your photo happy again.

Guiding Corrections with Help from a Histogram

Although you strive to capture good photographs, you might not always succeed. With the advent of LCD screens and digital image capture, seeing the just-taken photo allows you the opportunity to shoot the scene again if necessary. But what if the subject has moved or the lighting has changed? Editing in software, such as iPhoto '09, can often save the situation.

As with any endeavor that is part technical and part art, there is always room for interpretation and multiple tries. These guidelines for making corrections are meant as just that, a starting place. Feel free to "season to taste," but remember the idea is to have the correct amount of exposure so there is detail in the shadows and the highlights and the overall photo looks pleasing.

If you haven't already done so, I recommend following the steps in the preceding section to straighten and crop your photo before proceeding with this section.

What is a histogram?

Photographers use histograms as an aid in seeing, graphically, how the tones captured in a photo are distributed (from shadows through the midtones to the highlights) and whether image detail has been lost to blown-out highlights or blacked-out shadows. With a little experience and experimenting, you can look at a photo's histogram and get a very good idea of what controls you need to adjust to make the best possible picture.

When taking photos, your iPhone camera's sensor records light (called photons) linearly. That means if the light reaching the sensor from one area of the scene is twice as bright as another area, the sensor records it as twice as bright (twice as many photons), which may leave the photo without much highlight detail.

Our eyes, on the other hand, are non-linear, which means if we look at a scene that is twice as bright as another we know that it's brighter, but we don't see it as *twice* as bright; our eyes automatically adjust in a way the camera sensor cannot. Just be aware that what you see in a scene with your eyes might not be what the iPhone camera records. Have you ever experienced the situation where you took a photo of what you observed to be a beautiful scene and then been disappointed with the result? This difference between your eyes and the sensor could be the cause.

Figure 6-9 shows the top of the Adjust tool window, which is where the histogram appears.

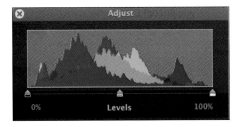

Figure 6-9: Example of a histogram.

Along the horizontal axis, the histogram shows the light levels (from darkest to lightest) for each color channel in the camera: red, blue, and green. The highlights area is depicted on the right of the histogram with the midtones in the center and the shadow area on the left.

Along the vertical axis, the relative number of pixels in the photo at each light level is shown by the height of the curve. The taller the curve, the more pixels in the photo at that light level. The histogram shows a lot of pixels in the shadow area, indicating a reasonable amount of detail there. It also shows plenty of pixels in the midtones and highlight values that just approach the right edge.

While you move the controls in the Adjust window (discussed later in this chapter), you see the effect of those movements in both the histogram and the photo. Therefore, the more you use the histogram the more you see how it can help you improve your photos.

Using a histogram

Remember the saying, "There's no substitute for experience?" What that means to me is that you gain experience by attempting, failing, changing your process, and eventually succeeding. That path isn't always easy, but when dealing with techniques where you make subjective decisions, sometimes it's the best way. To understand histograms, use one to make changes, see the results, and then adapt your changes based on those results.

Follow two basic guidelines when making your adjustments:

✓ Do not allow the histogram values to go beyond the right or left edges of the window (because you then run into the limitations of the sensor's ability to record the image) but do try to get them as close as possible by adjusting the sliders. The Adjust tools that alter the histogram values along the horizontal axis are exposure, highlights, and shadows.

✔ Try to keep any of the curves from flattening against the top of the histogram window when you make your adjustments. All the controls interact but, specifically, saturation and contrast might do this.

Figure 6-9 shows the histogram for a nicely exposed photo. The closer you can come to this example the better your photos will look. On the other hand, if you look at the histogram in Figure 6-10, you see a very uneven distribution of pixels. Almost all the pixels in the photo represented by the histogram are in the shadow area, meaning that the photo will be dark with very little, if any, detail in the midtones and highlights. Unless you're trying to do this for a specific purpose (generating a mood), this situation should be avoided.

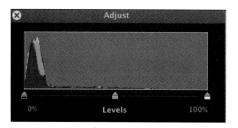

Figure 6-10: Histogram for an underexposed photograph

When using any of the Adjust tool's sliders, keep looking at both the histogram and the photo to see the results while you are making the change. Sometimes trying to make things better ends up making them look worse.

Making Photo Adjustments

In this section, I show you a hands-on approach to correcting flaws in your photos using the iPhoto Adjust tool. The more you learn about the Adjust tool, the better you identify areas to correct and adjust properly.

When you use iPhoto's Adjust tool, you enter the realm of subjective evaluation. There really aren't any "magic settings" that guarantee a great photo. Ask yourself whether the settings make the photo look like the scene you captured and whether you like how the photo looks. If the answers are yes, you have the correct settings for this photograph.

Until you gain some experience with using the Adjust tool, I strongly recommend you follow all the steps in this section in the order I list them. You may not need to perform all the photo adjustments for every photo, but try each adjustment to judge whether it's needed.

Fixing a color cast

You've probably seen photos where there seems to be an overall color tone, as though someone had taken the photo through a colored filter. This is called a *color cast* and is usually caused by a lack of white balance by the camera (see Chapter 4). If you have an iPhone 3GS or 4, the firmware in the camera will automatically white balance your photos. For the iPhone 3G and earlier models, no automatic white balance is available. If you get a color cast in your photo, do the following before making other corrections:

1. **Open your photo in Edit mode by double-clicking the photo or clicking the Edit button on the iPhoto toolbar.**

2. **Click the Adjust button on the toolbar at the bottom of the Edit pane.**

3. **In the Adjust window, click the eye-dropper button to the left of the Tint control, as shown in Figure 6-11.**

 The mouse pointer turns into a cross-hair.

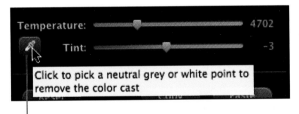

Eye-dropper button

Figure 6-11: The eye-dropper for correcting color cast.

4. **Click a white or gray area in the photo. If neither white nor neutral gray exists in the photo, try to find a neutral color that will work. This can be trial and error.**

 While you make your selections with the eye-dropper, both the Tint and Temperature sliders adjust automatically to attempt to remove the color cast.

5. **If the photo is still not corrected (the color cast might even look worse), don't panic. Click another area that you feel is neutral.**

 The overall look of the photo will change while you click areas of the photo. Usually, two or three choices of neutral areas will be all it takes. Sometimes, what looks neutral to our eyes has some color in it — just another example of the difference between our eyes and the camera. You just have to try and find the part of the photo that removes any color casts.

6. **If this process doesn't work on a particular photo, try manually adjusting the Temperature and Tint sliders to remove the color cast. The movements required will usually be small ones.**

 After you complete the color balancing, make sure you don't change the Temperature or Tint sliders, or you might have to color balance again.

7. **Press the Shift key to compare the current photo to the original photo.**

8. **If you're satisfied with your changes, click the Done button on the toolbar at the bottom of the Edit pane or continue with other changes using the Adjust tool.**

Adjusting exposure, contrast, and definition

Regardless of the iPhone model you own, it's amazing how this electronic device, which is first and foremost a smartphone, can do such an incredible job of making compromises so your photo is at least viewable, even though you might be capturing a scene in the worst of photographic circumstances.

These compromises, however, are made in a split second. You, on the other hand, have an opportunity to take your time, use your eyes and your creative intuition to make the changes you wish you could've foreseen when capturing the shot. See how this works by getting acquainted with the controls you'll be using:

- **Exposure:** The Exposure control, as the name suggests, allows you to modify the photo's overall lightness or darkness as though you had changed the shutter speed and/or aperture on the camera when the photo was taken.

- **Contrast:** The Contrast slider controls the degree of difference between the light and dark areas of your entire photo. It affects contrast on all areas of your photo equally. Increasing the contrast increases the difference between the light and dark areas. Decreasing the contrast decreases the difference.

- **Definition:** The Definition control adjusts *local contrast* (contrast in parts of the photo), which can help you improve clarity and also reduce any haze present in your photos.

I show the Saturation control later in this section.

The Exposure, Contrast, and Definition sliders are initially set to 0 (no effect on the photo), as shown in Figure 6-12.

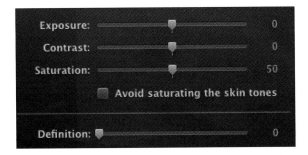

Figure 6-12: Exposure, Contrast, and Definition sliders set to 0 by default.

The Exposure slider provides very critical adjustments, and you can even recover some of the highlights that have been overexposed by using negative values. Remember that half the data values captured by the camera sensor are in the highlight area, so it's important to use as much of that data as possible.

To recover some highlight detail and save an otherwise overexposed photo, try these steps:

1. **Open your photo in Edit mode by double-clicking the photo or selecting the photo and clicking the Edit button on the iPhoto toolbar.**

2. **Click the Adjust button on the toolbar at the bottom of the Edit pane.**

3. **Use the Adjust window to perform a color balance. (See the earlier "Fixing a color cast" section for more details.)**

 Figure 6-13 is an example of the overexposed photo I'm using to show you this process. I already applied a color balance to the photo, but some bright areas have little or no detail.

4. **Move the Exposure slider and watch the histogram to see what happens.**

 It's best to move the slider with the mouse to get an idea of the direction and amount required. In this example, −1.05 seems to be about right and restores some cloud highlight detail.

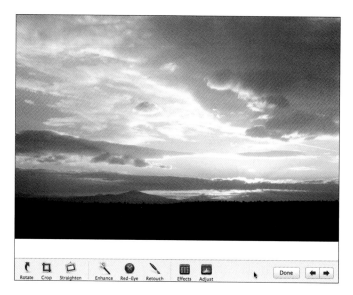

Figure 6-13: An overexposed photo.

5. **Move the Contrast slider to further enhance the photo.**

 For this example, a value of +6 looked about right. This is a subjective adjustment so you might use a different value. Basically, you want enough contrast to make the photo "pop" but not so much that it looks overly harsh.

6. **Drag the Definition slider until your photo looks the way you want it. This control can enhance details and eliminate haze from the photo. A value of 35 made the cloud detail near the sun more apparent.**

 Try going back and reducing Contrast after you adjust Definition. Repeat, if necessary, between Exposure and Contrast. Always work the controls until you achieve the look you want. Press the Shift key to compare the original photo to the current version. In this example, the photo is much improved already. Figure 6-14 shows the effect of all three changes and the Adjust tool window.

7. **If you're satisfied with your changes, click the Done button on the toolbar at the bottom of the Edit pane or continue with other changes using the Adjust tool.**

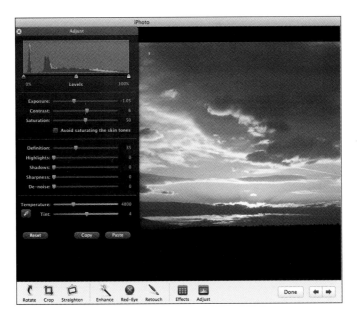

Figure 6-14: After making exposure, contrast, and definition changes.

Balancing highlights and shadows

The Exposure control described above was used to restore highlight detail in Figure 6-14. The Highlights control regains even more detail. Additionally, the Shadows control lightens just the shadows restoring more detail there, too.

Look at your photo and decide whether further alteration is warranted. You can get to a point where you're doing more harm than good. If you decide to make more adjustments, make them with the photo at 100% magnification. This allows you to see exactly what each change is doing.

To restore highlight and shadow detail:

1. **Open your photo in Edit mode by double-clicking the photo or selecting the photo and clicking the Edit button on the iPhoto toolbar.**

2. **Set the magnification of the photo using the slider in the lower-right corner just below the toolbar.**

 Place the slider in the center of its range.

3. **Move the Highlights slider (see Figure 6-15) with the mouse while watching the photo for changes.**

This allows you to get a feeling for the amount of highlight darkening you want to apply, which will bring out more of the highlight detail in your photo.

Figure 6-15: The Highlights and Shadows controls.

4. **When you're satisfied with the setting in the area you're observing, look at another highlight area and see how that looks.**

 Don't be afraid to try different settings of the Highlights control while looking in this new area to make sure that whatever value you apply is best for the entire photo, not just part of it.

5. **Zoom to the minimum magnification that allows you to see how the entire photo looks with the change you made. Then return to 100% magnification and recheck each highlight area.**

 Don't forget you can press the Shift key to see a comparison of the current photo and the original.

6. **Use the Shadows control to lighten the shadow areas if they are too dark and lacking in detail.**

 Again, zoom to 100% magnification and concentrate on a shadow area that seems too dark.

7. **Move the Shadows slider with the mouse to get an idea of how much shadow lightening you want to apply.**

 The idea is to provide some detail in the shadows, enough so the eye can recognize there's something there other than a black smudge.

8. **Press the Shift key to compare the current photo to your original.**

9. **If you're satisfied with your changes, click the Done button on the toolbar at the bottom of the Edit pane or continue with other changes, using the Adjust tool.**

Figure 6-16 shows how the photo looks after these changes. As you can see, more detail is evident in the highlights and shadows.

Figure 6-16: After making highlights and shadows changes.

Modifying saturation levels to enrich your colors

No matter how artsy the results are supposed to be, I'm not a fan of cranking up any editing tools to the point that the colors in a photo become unrealistic to the viewer. I do believe, as do most professional photographers, that the final photo should represent what the photographer saw the moment of capture and that corrections made to the digital image are appropriate and recommended based on the histogram.

Three controls in the Adjust window can dramatically affect colors — Saturation, Temperature, and Tint, as shown in Figure 6-17.

If you already color balanced a photo (see the earlier "Fixing a color cast" section), Temperature and Tint were automatically adjusted. Temperature affects the coolness or warmth of the colors in the photo. Moving the Temperature slider to the left introduces more blue (colder), and moving it to the right introduces more yellow (warmer). Moving the Tint slider left increases the red tint and moving it to the right increases the green tint of the photo.

Unless you want to undo the color balance or make very small adjustments to it, don't adjust the Temperature and Tint controls. Doing so can re-introduce a color cast. If you did a color balance (see the earlier "Fixing a color cast" section), you won't need to adjust these sliders any further.

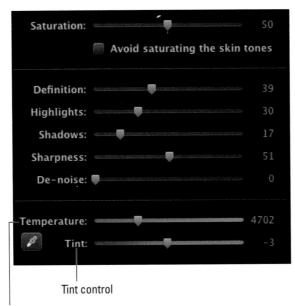

Tint control

Temperature control

Figure 6-17: The Saturation, Temperature, and Tint controls.

You'll use the Saturation control most frequently. Saturation describes the richness and intensity of the colors in your photo. Unfortunately, adjusting saturation can adversely affect skin tones; therefore, if you have people in your photo, select the Avoid Saturating the Skin Tones checkbox. This will allow you lots of saturation latitude without ruining skin tones.

1. **Open your photo in Edit mode by double-clicking the photo or selecting the photo and clicking the Edit button on the iPhoto toolbar.**

 iPhoto displays the photo in Edit mode.

 It's best to use the Adjust tools discussed earlier in this chapter first. If you haven't already tried them, get familiar with the Tint's eye-dropper for color balance and the Exposure, Contrast, Definition, Highlights, and Shadows controls.

2. **Click the Adjust button on the toolbar at the bottom of the Edit pane to open the Adjust window.**

3. **In the Saturation section of the Adjust tool, select the Avoid Saturating the Skin Tones check box if you have skin tones in the photograph.**

 This allows you to increase saturation without destroying the subtle facial and body tones.

4. **On the toolbar at the bottom of the Edit pane, set the magnification at the minimum value that allows you to see the entire photo. Then, with the mouse, move the Saturation slider to the right to increase color saturation or to the left to decrease it.**

 The histogram at the top of the Adjust window shows that this slider mostly affects the mid-tones.

5. **Watch your photo to see the changes that occur.**

 Keep in mind what you saw when you captured the photo so you can make your adjustments to re-create that look for the viewer. Typically, your settings will be between 40 and 65.

6. **Press the Shift key to compare the current photo to the original.**

 Happy with the result? Then you're done. Otherwise, continue with adjusting the saturation.

7. **If you have no other changes, click the Done button on the toolbar at the bottom of the Edit pane.**

Now you know how to correct the color in your photo.

Sharpening adjustments to make your photos sparkle

Any type of pixel editing, especially when it involves post-capture exposure adjustments, can cause a softening of the image. iPhoto provides the Sharpness tool for handling this situation. Figure 6-18 shows the Sharpness control in the Adjust window.

| Sharpness: | 51 |
| De-noise: | 16 |

Figure 6-18: The Sharpness and De-noise controls.

Here's how it works:

1. **Open your photo in Edit mode by double-clicking the photo or selecting the photo and clicking the Edit button on the iPhoto toolbar.**

 iPhoto displays the photo in Edit mode.

2. **Click the Adjust button on the toolbar at the bottom of the Edit pane to open the Adjust window.**

 3. **Set the magnification of the photo to at least 100% (halfway) using the slider in the lower-right corner just below the toolbar.**

 A small Navigation window appears, as shown in Figure 6-19, which makes navigating magnified photos easier. Inside the Navigation window is a highlighted rectangle. To move around in your photo, hover the mouse on the rectangle, press and hold the mouse down, and then move the mouse around in the window.

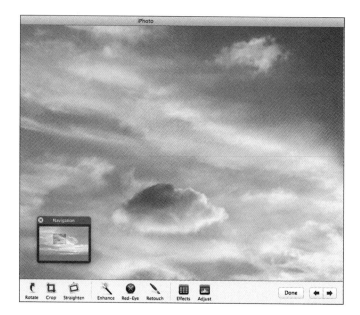

Figure 6-19: The Navigation window.

 Sharpness is one tool where magnification is absolutely required. Make sure your photo is set to at least 100%.

 4. **Pick out something in the photo with edges (using the small Navigation window to move the photo around) and then vary the Sharpness control's setting while watching the photo.**

 In this example, I chose the cloud edges.

 For sharpening, it's best to watch the photo while you move the slider to get a feel for how your photo is responding. While you move the slider, look at the edges of the object you zoomed in on. A sign of over-sharpening is a halo or blossoming effect along the edges of leaves, mountains, or clouds. If you see this, reduce the amount of sharpening. Otherwise, the rule here is "sharpen to taste" but use only as much sharpening as necessary.

This control is meant to correct for a softening in the look of the photo. It can't correct for a photo that was out of focus at the time of capture.

5. **Press the Shift key to compare the current photo to the original.**

6. **If you have no other changes, click the Done button on the toolbar at the bottom of the Edit pane.**

Removing noise distortion from your photos

Noise is a distortion in your image. In some ways it's similar to film grain. Electronic noise shows up as extraneous pixels sprinkled throughout an image and looks like confetti.

Dealing with noise in the digital age is a fact of life. Eliminating or lowering the amount of noise in your photos is another reason for making correct exposures at the time of capture. An underexposed photo has more noise than one that's correctly exposed. And when performing exposure corrections in iPhoto, that noise can become more noticeable, especially in the shadow areas.

Additionally, noise is a function of ISO, or the sensitivity setting of your camera. See Chapter 5 for a description of ISO.

All digital photos have noise, but it's important to understand the noise you see in iPhoto under magnification might not be visible when you view your photos or make small prints. The objective is to reduce noise so it isn't visible or damaging. Because it is very difficult to see noise in print, I'm not showing any examples in the following step list. See Chapter 5 for an example of electronic noise.

Color noise, especially in the shadow areas, looks something like confetti, with color speckles visible even at 100% magnification. To reduce noise as much as possible, do the following:

1. **Open your photo in Edit mode by double-clicking the photo or selecting the photo and clicking the Edit button on the iPhoto toolbar.**

 iPhoto displays the photo in Edit mode.

2. **Click the Adjust button on the toolbar at the bottom of the Edit pane to open the Adjust window.**

3. **Set the magnification of the photo to at least 100% (halfway) using the slider in the lower-right corner just below the toolbar.**

4. **Using the small Navigation window to move the photo, look in the shadow areas of your photo for evidence of noise.**

 If you don't see noise at this magnification, it's unlikely any noise will show up in a print, even a fairly large one.

5. **If you do see noise, watch that area of the photo and use the mouse to move the De-noise slider to the right (refer to Figure 6-18).**

Don't overdo it because noise reduction also has a smoothing effect on the photo, negating some of the sharpening you might have already done.

6. **Check all areas of the photo to ensure that you eliminated the noise problem as much as possible.**

7. **Press the Shift key to compare the current photo against the original to gauge how much noise reduction you've done.**

8. **After you finish, click the Done button on the toolbar at the bottom of the Edit pane.**

Trying effects — just for the art of it

In addition to recording an event, capturing a nature photograph, or snapping a beautiful landscape, you can also add interesting effects and just plain fun to your photos with iPhoto's Effects tool.

The Effects tool is next to the Adjust tool on the toolbar at the bottom of the Edit pane. The Effects window displays nine versions of your photo: each effect you can apply and the original photo. Figure 6-20 shows the Effects window.

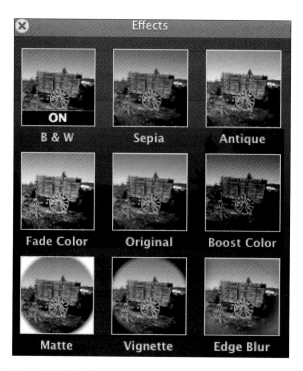

Figure 6-20: The Effects window.

iPhoto '09 allows you to activate multiple photo effects at the same time. Say, if you click B & W and then click Vignette, both B & W and Vignette are applied to the photo. However, only one effect from the first row (B & W, Sepia, and Antique; refer to Figure 6-21) can be on at a time. As for the other effects, the more the merrier! If you want to start over, click the Original effect to cancel any effects you previously activated.

The nice thing about the Effects window is that you can try each effect (except the first row), one after the other, without having to change any other settings. Here's an example:

1. **Open your photo in Edit mode by double-clicking the photo or selecting the photo and clicking the Edit button on the iPhoto toolbar.**

2. **Click the Effects button on the toolbar at the bottom of the Edit pane.**

 The Effects window opens and shows a thumbnail of your photo with each effect applied so you have an idea of what each one does. Figure 6-21 shows the photo I chose before applying any effects.

Figure 6-21: Photo before using the Effects tool.

3. **Click the B & W (black and white) effect in the Effects window.**

 An On button appears at the bottom of the B & W effect in the Effects window. You can click it to remove (turn off) the B & W effect. Figure 6-22 shows you what this effect looks like when applied to the photo. You can also try manipulating the Saturation slider in the Adjust window to augment this effect.

Figure 6-22: Result of the B & W effect.

4. **Click the Original effect and then click Sepia to turn on the Sepia effect.**

 An On button appears; you can click it remove the Sepia effect. Figure 6-23 shows you the result of this effect.

Figure 6-23: Result of the Sepia effect.

You can always press the Shift key to compare the current photo to the original.

5. **Click the Original effect and then click Vignette to turn on the Vignette effect.**

 The number with small arrows on either side allows you to increase or decrease the power of the effect. Figure 6-24 shows the result of this effect at level 1.

Figure 6-24: Result of the Vignette effect.

I think you get the idea of how this works. You can click multiple effects and combine them on a single photo. This takes some experimenting to get a desired effect, but the effects in iPhoto '09 really open the creative doors.

Saving your photo adjustment settings

When you take a series of photos in the same lighting conditions, the photos often lend themselves to the same Adjust tool corrections. Therefore, you may apply similar Adjust tool settings to the other photos. Do you have to repeat the process with each photo? Luckily, the answer is no.

You can save your Adjust tool settings and then apply them to the other photos. Doing so puts you close to the right settings where you then can make minor individual corrections. Here's how:

1. **Open your photo in Edit mode by double-clicking the photo or selecting the photo and clicking the Edit button on the iPhoto toolbar.**

2. **Click the Adjust button on the toolbar at the bottom of the Edit pane.**

3. **Make your corrections to the photo.**

4. **Click the Copy button at the bottom of the Adjust window, as shown in Figure 6-25.**

Figure 6-25: The Copy and Paste buttons.

5. **Use the arrows next to the Done button to view another photo or click the Done button and then select another photo to display in Edit mode.**

Figure 6-26 shows the selection arrows.

Figure 6-26: Photo selection arrows on the toolbar at the bottom of the Edit pane.

6. **After you select the next photo, click the Adjust button and then click the Paste button at the bottom of the Adjust window (refer to Figure 6-25).**

That's it! Your previous corrections will be applied to the new photo. You can continue to do this as long as you don't quit iPhoto or click the Copy button again. Unfortunately, there is no way to save multiple sets of corrections.

Part III
Picking Great Accessories

"Of course your iPhone lets you watch videos, listen to music, and surf the Web. But does it shoot silly string?"

*C*amera phones, the iPhone camera in particular, have come a long way in a very short time. The increasing number of pixels (3 megapixels in the 3GS and 5 megapixels in the iPhone 4's rear camera) and the more sophisticated firmware and software available for the iPhone provide consumers with the opportunity for striking photography.

Advanced photography with the iPhone requires some additional accessories that are becoming more available. In Chapter 7, I discuss tripods and other equipment that make your iPhone more stable for crisp photographs and multiple photos of the same subject for High Dynamic Range manipulations (see Chapter 5). For the iPhone 3G/3GS, supplementary lighting can be a lifesaver for low-light photography, and I show you some examples. Supplementary lighting and some display devices (for showing your iPhone photography when you're away from your computer) are also discussed.

Chapter 8 reveals accessories for zooming in on your subject with the iPhone, including a variety of zoom and wide-angle lenses that are available.

7

Stabilizing, Lighting, and Projecting

In This Chapter

▶ Taking photos with an iPhone tripod

▶ Using external lights with your iPhone

▶ Taking a pocket projector along to display your photos

*H*aving a phone, a still camera, and a video camera all in one shirt or jacket pocket is a great convenience. That doesn't even take into account the photography applications that give the iPhone some capabilities normally available only on computers. I discuss some of these applications in Chapters 9 and 10.

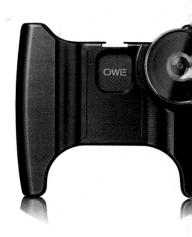

Additionally, an absolute fact is the better the original photograph, the better the final result. Two major factors in capturing a good photograph are camera stability and lighting. Whether you want to hold the camera steady or take your own photo, a tripod is indispensible. The iPhone 3GS and iPhone 4 can handle low-light situations (the iPhone 4 even provides its own flash), but the other iPhone models require getting some light on the subject. Are there tripods and lights that are appropriate for the iPhone? The answer is yes, and though I don't fully review each device, I want you to appreciate your iPhone's advanced photography capabilities. Obtaining these accessories adds to the cost of your iPhone but may be worth it by enhancing your photo capabilities.

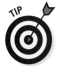

TIP

As you can imagine, accessories and applications for the iPhone are updated continually. Manufacturers have said they are in the process of updating their products for the iPhone 4, but none are currently available for testing. Although the descriptions in this book are current, more up-to-date information might be available on my blog at www.scenesfromthewest.com or from the respective product's Web sites.

Adding a Stable Base with the Gorillamobile 3G/3GS

When you're snapping photos with your pocket-size iPhone, the last thing you want to do is lug around a five-pound tripod. Well don't worry, several tripod solutions can fit in another of your pockets. Figure 7-1 shows the Gorillamobile 3G/3GS tripod and its accessories, including a protective back for the iPhone and several connectors.

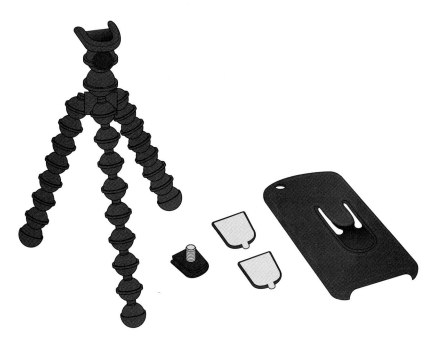

Figure 7-1: The Gorillamobile 3G/3GS tripod system.

To connect your iPhone 3G/3GS to the Gorillamobile, follow these steps:

1. **Put the iPhone 3G/3GS into the protective case.**

 The iPhone 4 version of the case, when it's available, will have an additional opening for the LED flash.

2. **Slip the notched connector in the center of the case into the tripod head until you hear a click.**

 You now have a safe coupling. There is a button at the top of the Gorillamobile that must be pressed when you want to remove the iPhone. Additionally, a lock-ring makes it impossible to accidentally push the button and remove the iPhone.

Figure 7-2 shows an iPhone 3GS on a Gorillamobile tripod. The case is made so that all the controls and the 30-pin dock connector in the bottom of the iPhone are accessible. The connector lets you plug your USB cable (for syncing and charging) into the iPhone — even when it's mounted on the tripod.

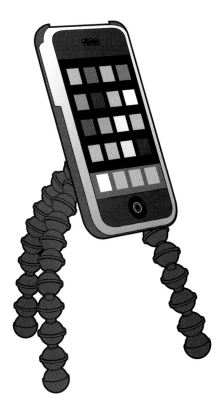

Figure 7-2: An iPhone mounted on the Gorillamobile.

If you aren't using your iPhone 3G/3GS to take a photograph, a Gorillamobile is a convenient way to mount your iPhone for other uses, such as listening to music or the ballgame. The flexible legs and rubberized feet make it ideal for wrapping around table legs, poles, or other sturdy fixtures either indoors or outside. And like the iPhone 3G/3GS, a Gorillamobile fits in your pocket! More information is available at http://joby.com/gorillamobile/3g.

The App Store has a free Gorillacam application that has several photographic capabilities that come in handy. See Chapter 9 for more on the Gorillacam app.

Working with the OWLE Bubo for 3G/3GS

Although the name OWLE bubo might make you look quizzical and check whether I made a spelling error, using the OWLE bubo will put a smile on your face. Figure 7-3 shows this unusual but very handy and powerful device.

I have been told by the manufacturer that it expects to have an iPhone 4–compatible version available in the latter half of 2010.

You're probably thinking that this doesn't look like your daddy's tripod, right? That's because it's a whole lot more than that. It has an aluminum unibody construction, so it's not fragile. On the back of the device, directly in the center, is a soft rubber, removable case that you put your iPhone 3G/3GS into and then snap the case into the OWLE in the landscape orientation. This makes the entire screen accessible for touches, including thumb-touch operation in camera mode. You hold the device by the two legs at the bottom. I find that the Gorillamobile case (which I leave on my iPhone 3GS all the time) also fits beautifully into the OWLE.

Other OWLE bubo features include the following:

- **Mount for additional light:** A cold-shoe mount at the top can hold an accessory LED light for shooting in low-light conditions. Two models of lights and other accessories can be found at `http://wantowle.com`.

- **iPhone charging and syncing:** An opening on the right side of the bubo allows the connector cable to charge or sync the iPhone while it's in the bubo.

- **Stability:** The four posts at the corners are threaded with 1/4-20 threads so the bubo can connect to a standard tripod. But when hand-held, the size, weight, and design make it a very stable platform for photos and video.

- **Optional lenses:** Take another look at Figure 7-3. On the front, a combination macro/wide-angle lens (that's included) can be attached to the bubo. The 37mm threaded lens mount allows you to add other lenses as well. (Just under the lens and to the lens's left is the on-board microphone.) Because the macro/wide-angle setup is actually two separate lenses, you can remove the wide-angle lens and get fantastic close-ups with the macro lens. Of course, you can remove both lenses and just go with the regular camera lens.

The OWLE bubo (`www.wantowle.com`) expands the type and quality of photos you can take and provides excellent stability and wide-angle capability. It's priced at $129, but to take iPhone 3G/3GS photography to the next level, it's highly recommended.

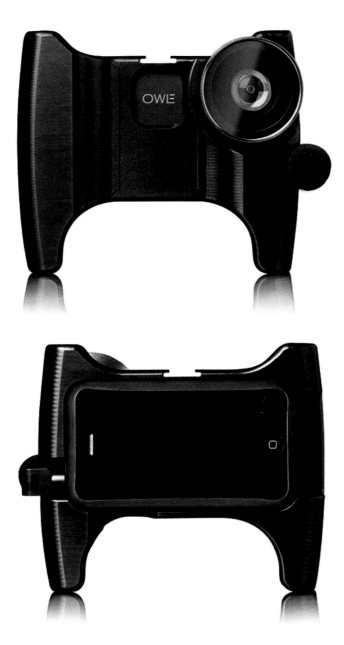

Figure 7-3: Front (top) and back (bottom) views of the OWLE bubo.

Casting Supplemental Light with the Gorillatorch

Having no flash can make photography difficult in low-light situations with the iPhone and iPhone 3G. Sure, the 3GS lets you change the exposure and white balance, but not having enough light increases the chances of color noise (see Chapter 5) and poor focus.

As mentioned in the preceding section, the OWLE has a cold-shoe mount for accessories, including two different LED lights. If buying the OWLE is not of interest, consider the Gorillatorch (shown in Figure 7-4). Made by the people behind the Gorillamobile I discuss in the earlier "Adding a Stable Base with the Gorillamobile 3G/3GS" section, the Gorillatorch has the same stand design. This light also functions as a flashlight; therefore, the light is directed rather than diffused. Additionally, there's a dimming feature that might fit your lighting needs. For more details go to `http://joby.com/gorillatorch`.

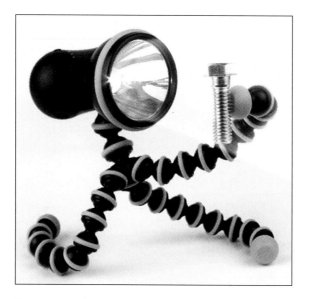

Figure 7-4: The Gorillatorch.

In Figure 7-4, you can also see that the flexible legs have magnetic feet to give you additional ways to fix your lighting in place.

Figure 7-5 shows the Gorillatorch head and the graduated intensity selector for setting the amount of desired light.

Full output of the Gorillatorch's CREE LED is 65 lumens. At around $30, it's a handy light for photography and many other uses.

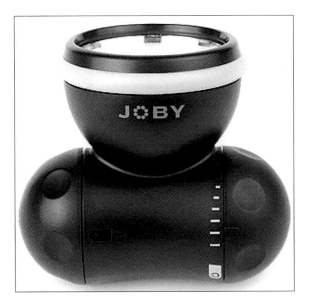

Figure 7-5: Gorillatorch head with intensity switch.

Showing Your Photos with a Pocket Projector

As you already know, one of the great things about the iPhone, besides its versatility, is that it is very transportable, fitting easily into a shirt or jacket pocket. And the storage is sufficient to allow you to keep large numbers of photos and videos in the Camera Roll and Photo Library.

Letting one of your friends look at your photos and videos works well enough, but there might be times when you want to display your photos to a group. Usually that means lugging a relatively large piece of equipment with you, which offsets the portability of the iPhone.

Enter the *pocket projector.* Two of these nifty little machines are available: the Optoma PK201 pocket projector and the Microvision SHOWWX laser projector. Both projectors are approximately the size of the iPhone (forget portability problems), run on lithium-ion batteries, and connect into the 30-pin connector on the bottom of the iPhone.

Although the Optoma uses DLP technology (used in TVs) and the SHOWWX uses laser technology, both can project an image on just about any surface, so you don't have to carry a screen!

The Optoma PK201, shown in Figure 7-6, has a resolution of 854 x 480, can project an image to a size of 66 diagonal inches, and costs $299. More information is available at www.optomausa.com.

Figure 7-6: The Optoma PK201 pocket projector.

The SHOWWX laser projector has a resolution of 848 x 480, can project an image up to 100 diagonal inches, and costs $550. See Figure 7-7. More information is available at www.microvision.com.

Figure 7-7: The SHOWWX laser projector.

Another entry in the field is the Cinemin Swivel projector (see Figure 7-8), which also uses DLP technology to display your iPhone images at up to 60 inches in size. Again, being a small device makes carrying it a joy.

Figure 7-8: The Cinemin Swivel projector.

Although the Swivel projector has many things in common with the previously described projectors, a couple of features set it apart. As you can see in Figure 7-8, it's called the Swivel for good reason — because it, well, swivels. You can easily change the angle of projection while leaving the projector flat on a surface, which comes in really handy.

The Swivel is bundled with an iPhone 30-pin adapter, an AC power adapter, a headphone jack for external audio, and a rechargeable battery good for two hours. Native resolution is 480 x 320 on the Swivel, which costs less than $300.

These projectors are useful for showing photos to family and friends but can also be used on business trips for showing presentations to customers.

With airlines increasing the costs of checked baggage, being able to put your presentation materials and display equipment literally in your pocket seems like a game-winner.

8

Getting Some Zoom on the iPhone

*Y*ou're probably wondering if I've lost my mind writing about zooming on an iPhone! But think about the possibilities. You already have the iPhone with you just about anywhere you go. Having a lens that can get you closer to what you want to photograph without actually moving would be an easy way to improve your photo compositions. However, the majority of your photo-taking experience with the iPhone will probably be without an external lens.

The iPhone camera has a fixed aperture setting of f/2.8. The telephoto lenses I discuss in this chapter are really telescopes; they do not contain a shutter and are simply magnifiers.

There's no obvious way to attach external lenses or magnifiers to the iPhone. In Chapter 7, the OWLE bubo is discussed, which does provide a way of attaching lenses. In this chapter, you see another device that provides this capability for a relatively small cost. Lenses that attach to a connector glued onto the iPhone case are not covered because I do not recommend them.

Three lenses and lens holders are available. They're in no particular order and you can judge the appropriateness of each one for your situation based on the information given.

As you can imagine, accessories and applications for the iPhone are continually updated, especially now with the release of the iPhone 4. While the descriptions in this book are current, more up-to-date information may be available on my blog at www.scenesfromthewest.com or from the respective product Web sites.

Comparing Digital and Optical Zooming

In checking the photographic applications available for the iPhone, you may have noticed that several of them profess to provide a digital zooming capability, which sounds like it would be great. Some of you may be familiar with the difference between digital and optical zooming. For those who aren't, here is a brief discussion:

- **Optical zoom:** As the name implies, optical zoom uses the optics of a lens to actually bring the subject closer in the viewfinder while using all the resolution of the camera. Image quality depends on the quality of the optics.

- **Digital zoom:** With digital zoom, the camera essentially crops a portion of the image and then expands the cropped area to fill the viewfinder. However, this process loses image quality because only a part of the total screen resolution in your iPhone was captured and then the software expands it back to full size. To capture a spontaneous event, it may be useful to use your digital zoom.

 You can also do the same operation by taking a full photograph, importing the photo into iPhoto '09 at a later time, and then using the crop tool to achieve the same effect. Figure 8-1 shows a photo taken, hand-held, with no zoom. Figure 8-2 shows the result of using the crop tool in iPhoto '09 after getting back home. Figure 8-3 shows the same subject taken with digital zoom on my iPhone 3GS.

Figure 8-1: Original photo with no zoom.

The results in Figures 8-2 and 8-3 are similar because the same operation was performed — the first time in iPhoto and the second time on the iPhone 3GS. So, you can do whichever one makes the most sense to you.

Figure 8-2: Full scene cropped with iPhoto '09.

We're talking about a camera in a cell phone. You're probably not taking fine art photos. You're just trying to capture a moment, so if you'd rather use digital zoom and save your money for something else, it's okay. Just be aware of the trade-off you're making in not using an optical zoom and that digitally zoomed photos may not print well.

Figure 8-3: Digitally zoomed photo from original distance.

Using the OWLE with a Telephoto Lens

Chapter 7 covers the OWLE bubo, a secure mounting case for your iPhone 3G/3GS. In addition to the wide angle/macro lens that comes with the bubo, you can purchase any telephoto lens that has a 37mm screw-in thread.

Tiffen makes a 2X magnifier with the required 37mm thread for approximately $80. See Figure 8-4.

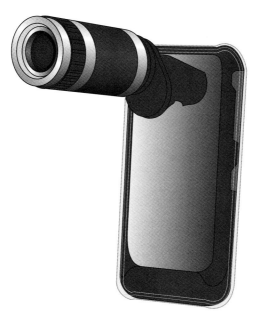

Figure 8-4: Tiffen 2X telephoto lens.

The iPhone Telephoto Lens

Last but not least, the iPhone telephoto lens system, available online from Hammacher-Schlemmer, consists of a telephoto lens, an iPhone 3G/3GS case, and a mounting tripod. (See Figure 8-5.) The black case, which snaps around the iPhone 3G/3GS, secures the lens to the iPhone. A universal attachment connects the mounting tripod to the iPhone 3G/3GS case so that the entire system is secure and stable.

The lens, which only works with the iPhone 3G/3GS, is a little more expensive than the 6X lens previously mentioned, but can be manually focused to ensure that the resulting camera image is sharp and offers a 16-degree angle of view. The cost is around $60 for the lens, case, and tripod and does give 8X magnification.

You might be wondering how big a difference such a lens can make in your photography. I used this lens system on my iPhone for a scene that was approximately 125 yards away. Figure 8-6 shows the view as seen through the normal iPhone 3GS lens. The red ellipse shows the area the telephoto lens will view.

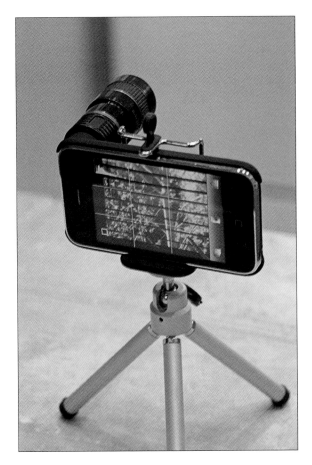

Figure 8-5: The iPhone telephoto lens system on my iPhone 3GS.

I then put on the 8X lens, and took the shot. I also let the iPhone 3GS do its autofocus and auto white balance for both photos. Figure 8-7 shows the difference. For a relatively inexpensive telephoto lens, it did a very nice job.

To get an idea of the difference between optical and digital zooming, I also took the same shot from the same spot using the digital zoom on the Camera app. Figure 8-8 shows the result. Indeed, the 8X telephoto lens is much clearer and able to zoom closer.

Hand holding such a lens is not recommended because shakiness will be magnified. The tripod that comes as part of the total package makes quite a difference.

When you look through online catalogs in the coming months, you may find other lenses and lens systems available for the iPhone.

Although iPhone cameras are used for spur-of-the-moment shots, there's no reason not to use other equipment to improve the photographs you take and make them the best they can be. Especially if the equipment is relatively inexpensive.

Figure 8-6: View through the normal iPhone 3GS lens.

Figure 8-7: View through the telephoto lens.

Figure 8-8: View using digital zoom in the Camera app.

Part IV
Understanding the Helper Applications

The 5th Wave — By Rich Tennant

"Other than this little glitch with the landscape view, I really love my iPhone."

*F*or all the sophistication and electronic wizardry that the iPhone has to offer, you might still want more; you're human after all. This is where the Apple App Store can help, with more than 200,000 helper applications available in a number of categories. These well-constructed and useful apps are often free. With apps you purchase, the fee usually ranges between just $1 and $3.

In this part, I concentrate on the apps that deal with photography. In Chapter 9, I tell you about the apps I consider most useful — free and for purchase. In Chapter 10, I show you some apps that allow you to do some tricks with your photos and have some fun.

9

Helpful Photography Apps for Your iPhone

*I*t certainly hasn't taken the App Store long to increase the number of applications to more than 225,000. Although not all of these apps are concerned with photography, currently, there are more than 400 photography-related apps!

In this chapter, I review a few apps that I find to enhance the iPhone photography experience. Sometimes, the app modifies and simplifies certain built-in operations; other times, the app provides capabilities the iPhone camera doesn't already have.

Perhaps the nicest part is that while there are many worthwhile commercial applications out there, I show you some free apps that may be all you need.

Checking Out the Free Applications

I can hear you. "Show me some apps that won't cost me anything." And that's a fine place to start. Here's a brief tour of a few of the most useful free photography-oriented applications out there.

Adobe Photoshop Express

Hard to believe this Photoshop app is free, but it is. The Adobe Photoshop Express application allows you to either work on a photo in your library or edit right after you take a new photo. You can also sign up for a free Photoshop.com account and store 2GB of photos/videos that you can access, view, and share from your iPhone. Tap the Adobe Photoshop Express icon on your iPhone, and Figure 9-1 shows the opening Edit screen where you choose to take a new photo or edit one in your Camera Roll or Photo Library.

Figure 9-1: Opening Edit screen for Adobe Photoshop Express.

Adobe Photoshop Express opens to the Edit screen by default. Along the bottom of the screen are four icons that do the following:

- **Edit:** This screen offers two buttons at the top that allow you to select a photo from your Camera Roll (or Photo Library) or take a new photograph.

- **Online:** Takes you to the Photoshop.com Web site where you can sign in to your account if you have one or create an account if you don't.

- **Upload:** Allows you to upload photos to the Photoshop.com, Facebook, or TwitPic Web sites.

✓ **Settings:** Allows you to set up automatic sign-in to the Web sites mentioned above. Additionally, when you use any tools, you can turn on an instruction screen that helps make operating them easier.

For this example, I chose Select Photo and used a photo from my Photo Library. Figure 9-2 shows the photo in a screen that has a large number of editing choices denoted by the icons at the top. These icons group the editing actions, such as exposure, saturation, tint, cropping, straightening, rotating, flipping, sharpening, and adding effects and borders.

Figure 9-2: You have many editing choices.

I can crop the photo, straighten any tilt, rotate the photo or flip it horizontally or vertically. After you choose an operation, you touch the screen and slide your finger right or left over the photo to apply your change. No slider appears; the operation is accomplished with just the movement of your finger.

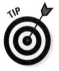

In your settings (described above), I suggest you turn on Tips, at least until you're familiar with the app's operation. This setting provides a small alert dialog that tells you what to do each time you select an operation. After you read the tip, just tap the Dismiss button. Figure 9-3 shows an example.

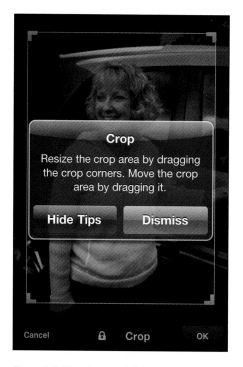

Figure 9-3: Tips give you brief operating instructions.

Figure 9-4 shows a composite of all the selections contained in the icons at the top of the screen.

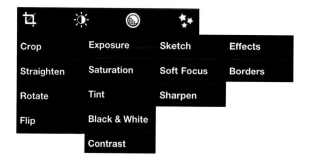

Figure 9-4: All possible editing operations.

Here's how to edit your photos in Adobe Photoshop Express:

1. **Take a photo (or select one from your library) using the buttons shown in Figure 9-1 and then tap one of the icons at the top of the screen.**

2. **Tap the operation you want to perform, such as Exposure.**

 The application automatically adjusts the exposure for the photograph and applies the change.

 If you don't like the change you just made, you can change it again by placing your finger on the screen and sliding either to the right or the left to increase or decrease the value for that operation.

3. **When you're satisfied with the edit, tap the OK button to accept the change; tap the Cancel button to cancel the operation (see Figure 9-5).**

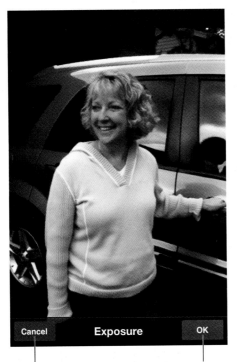

Cancel the change. Accept the change.

Figure 9-5: Exposure editing screen.

The application returns to the editing screen (refer to Figure 9-2). You're ready for another editing operation, or you can save your changes.

At the bottom of the editing screen is a counterclockwise arrow (a multi-level Undo) that allows you to change your mind about the operations performed on the photo all the way back to the original photo. Use the clockwise arrow (a multi-level Redo) for forwarding to the final operation. The button with an X exits editing without saving changes and returns you to the Edit screen (refer to Figure 9-1).

 4. **Save your changes by tapping the downward-facing arrow at the bottom right of the screen, as shown in Figure 9-6.**

 A menu of choices for saving or uploading appears.

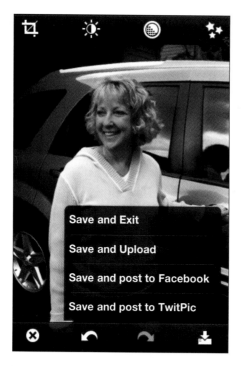

Figure 9-6: Saving or uploading your edited photo.

Very neat stuff and a very useful application for making changes right on your iPhone. Of course, you can also import your photos into iPhoto '09 to make changes on your Macintosh or into Photoshop Elements (Windows and Mac).

Adding pro style color tools with Mill Colour

Mill Colour is another free app you can use to enhance your photos on the iPhone. Figure 9-7 shows the opening screen.

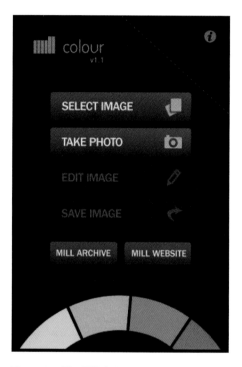

Figure 9-7: The Mill Colour main menu.

After you select a photo from your library or take a new photo, you have numerous combinations to choose from. For this example, I show you a few of the processes with one photo. These few steps will help you explore the app on your own.

To make adjustments to a photo in Mill Colour, follow these steps:

1. Tap the Select Image button.

Your Camera Roll and Photo Albums display. Find the photo you wish to work on.

2. **Tap the image you want to edit.**

 The image appears with the Looks and Colour Controls buttons at the bottom, as shown in Figure 9-8.

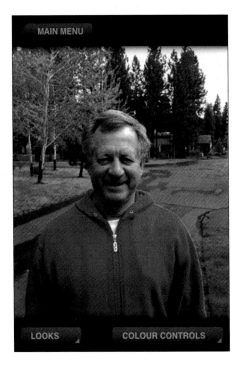

Figure 9-8: Choose Looks or Colour Controls.

3. **To select Looks, tap the Looks button.**

 A gallery displays several versions of your image with a different look ('70s, Noir, Bleached, Instant, Original, and many more) applied. You access the different looks by swiping your finger, left or right, across the screen. When you see the one you like, tap the Done button. To stick with the original image, tap Cancel. For example, Figure 9-9 shows the image with a '70s look.

Current Colour Control mode

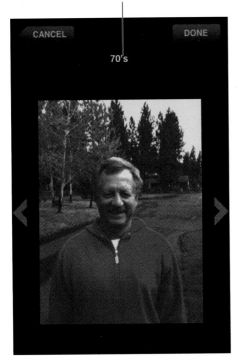

Figure 9-9: '70s look applied to the original image.

4. To make color changes to the photo, tap the Colour Controls button.

A screen similar to Figure 9-10 appears showing the color control for Saturation mode. In this app, you drag your finger on the ruler either left or right to increase or decrease values, in this case, Saturation. If you tap the Mode button again, you see a screen with buttons for selecting the other modes to work on. The modes are

- *Lift* modifies darker areas or black levels of the image.
- *Gamma* modifies the midtones of the image.
- *Gain* modifies the bright areas or highlights of the image.
- *Saturation* modifies the intensity of the colors.

Reset button

Done button

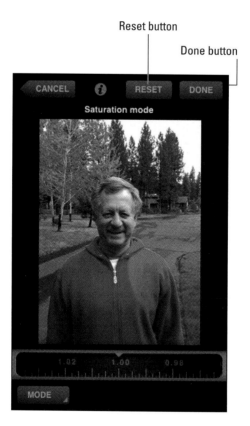

Figure 9-10: The Colour Controls Saturation screen.

When working with any of the color controls, you can always tap the Reset button at the top to start over with that control.

5. **When you're satisfied with your changes, tap the Done button shown in Figure 9-10.**

6. **Tap the Save Image button to save your edited image.**

 You're asked to confirm the save, as shown in Figure 9-11. Your corrected photo is now in your Photo Library on your iPhone.

The Mill Colour application gives you a large number of choices, and I encourage you to try them with your own photographs. I think you'll enjoy turning loose your creative side.

Figure 9-11: Confirm the save.

Adding features with Gorillacam

Even though your iPhone camera already takes amazing photos, you might want a few more bells and whistles. If you don't mind paying nothing for it, there's an app that can make your iPhone camera even better. That's right, Gorillacam is free and available at the App Store, and it's from the same folks who make the Gorillamobile discussed in Chapter 7.

When you open the Gorillacam application, tap the icon at the bottom left. This allows you to choose which options you want active, as shown in Figure 9-12. The button in the center is for the camera shutter, and the one on the right opens your Camera Roll for viewing. The second button from the left only appears if you set Anti-shake to On.

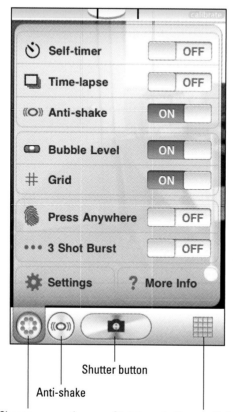

Shutter button

Anti-shake

Choose your options. Click to go to Camera Roll.

Figure 9-12: The Gorillacam app.

Your choices are

✔ **Self-timer:** Allows you to put the camera on a tripod, push start, and then get yourself into the picture. When you turn the switch to On, the Picker appears (see Figure 9-13) and lets you select the interval. At the right you see a vertical slider. This is the digital zoom control. Before using digital zoom, see Chapter 8 for a discussion of digital and optical zooming.

✔ **Time-lapse:** Allows a press of the Shutter button to generate multiple photos separated by an interval of your choosing. When you turn the switch to On, the Picker (see Figure 9-14) lets you select the number of photos and the interval between them.

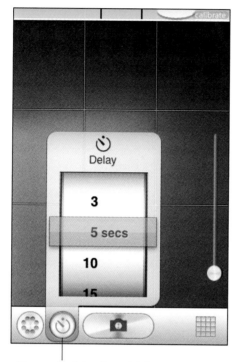

Choose the delay time with Picker.

Figure 9-13: Setting the self-timer delay.

✔ **Anti-shake:** Allows the camera to wait until the camera is steady before taking the photo. When you turn the switch on, you can set the sensitivity in the Picker to High, Medium, or Low. The High setting may cause many seconds to elapse after you tap the Shutter button before the photo is taken.

✔ **Bubble Level:** A bubble at the top helps you keep the camera level in both Portrait and Landscape orientations (refer to Figure 9-12).

✔ **Grid:** Superimposes a grid over the scene you are viewing to help with composition (the Rule of Thirds is discussed in Chapter 4).

✔ **Press Anywhere:** Causes the picture to be taken when you touch anywhere on the iPhone screen. If you have an iPhone or iPhone 3G, this works nicely. For the iPhone 3GS, it prevents selective focusing, and so this feature should be turned off.

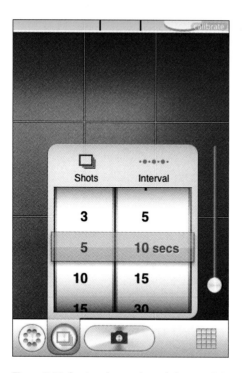

Figure 9-14: Setting the number of shots and the time-lapse interval.

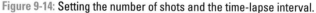

✔ **3 Shot Burst:** One tap of the Shutter button causes three photos to be taken, one after the other. This can be helpful when photographing an action scene.

✔ **Settings:** Figure 9-15 shows the Gorillacam settings you can adjust. You can save your photos to your albums at high resolution while using lower resolution for e-mail. You can choose to show the zoom control and switch the side where it appears. Turning Countdown Alarm on gives a three-second visual and audio signal before the photo is automatically taken.

You can also view the photos on your Camera Roll from this application. All in all, this gives your iPhone 3G/3GS a lot of extra functionality that's useful — and the price is right.

The App Store offers lots more free apps that can enhance your enjoyment of photography on the iPhone, and I encourage you to try them.

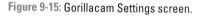

Figure 9-15: Gorillacam Settings screen.

Finding Useful Paid Applications

There's an old saying that you get what you pay for. Don't get me wrong, the applications preceding this section are incredibly valuable and useful even though they come at no cost. But some aspects of photography require more complex applications, and you usually have to pay for those. The good news is that even in the world of paid applications, the price (I think) is reasonable and much less than computer software.

Solving tough lighting situations with Pro HDR

When the contrast (the difference between the shadows and the highlights) in a photo you want to take exceeds the ability of the camera system to accurately capture it, you normally have to choose between properly exposed shadows or properly exposed highlights. This type of scene is said to have high dynamic range. The image produced by Pro HDR gives you a result with correct exposures for shadows and highlights.

In Chapter 5, I show you a way to handle a high dynamic range scene and produce a photograph with excellent detail in both the highlights and the shadows using the iPhone camera's HDR capability (in iOS 4.1) or third-party software. You can accomplish the same result on your iPhone 3GS or iPhone 4 from within the Pro HDR application. Nothing else is needed. Tap the Pro HDR icon on your iPhone to open it. Figure 9-16 shows the main menu.

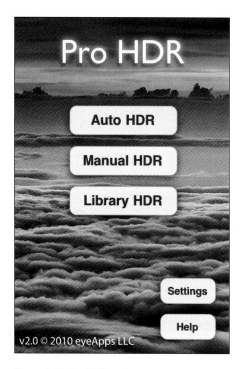

Figure 9-16: Pro HDR main screen.

Tap the Auto HDR button (one tap of the Shutter button takes the light and dark images automatically), the Camera HDR button (to manually take the light and dark images that will be blended), or Library HDR (to manually select a light and dark image from your Photo Library).

When using the app for the first time, tap the Settings button to indicate if you want to keep the original images and what resolution you want to use for saving and for sending the new composite photo in an e-mail. See Figure 9-17. My recommendation is to set Save HDR with Size to Full and E-mail HDR with Size to Small or Medium so you won't have a problem e-mailing the photos.

If you want to keep the light and dark images for later use, you must slide the Save Original Images switch to On. If you don't do this, only the blended image will be retained.

Figure 9-17: The Settings screen.

I mention in Chapter 5 that we often encounter scenes with a lot of contrast (for example, very bright areas and very dark areas). Our eyes and brains can accommodate this kind of contrast more easily than a camera, even an expensive one. So, what can be done in this situation?

Enter Pro HDR. Essentially, this application lets you take a photo exposed for the highlights and a photo exposed for the shadows (this is why it only works on the iPhone 3GS and iPhone 4). Then the program melds the correctly exposed parts of each photo to make one photograph. If you tap the Auto HDR button, the app automatically takes both photos with one tap of the shutter button. And you can still adjust the composite image.

Here are the steps if you want to manually create a composite image:

1. **Open the Pro HDR app by tapping its icon. Tap the Camera HDR button. Line up the camera so that the composition on the screen is the way you want it.**

 You can't move the camera between the two shots.

 The app displays a message asking you to tap somewhere bright. In Figure 9-18, I chose the sky in the background.

2. **Tap the Take Picture #1 button on the right side of the screen.**

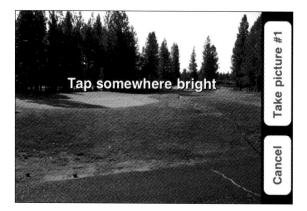

Figure 9-18: Picture #1 screen.

After that photo is captured, the application asks you to tap somewhere dark. I chose the trees on the left in Figure 9-19.

3. **Tap the Take Picture #2 button.**

 You no longer need to hold the iPhone still.

 Pro HDR then processes the two photos, aligning and blending them. When the app finishes processing, you see the screen shown in Figure 9-20. Notice the sky actually contained clouds that were not seen before and shadow detail in the tree area has also been enhanced. Now, if you wish, you can fine-tune the color adjustments.

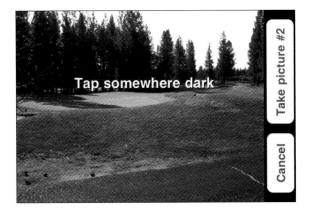

Figure 9-19: Picture #2 screen.

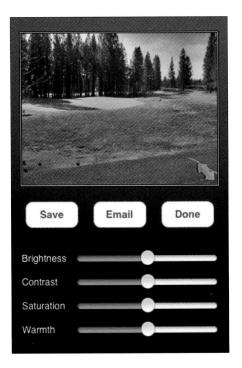

Figure 9-20: Adjust the color options.

From here you have several options, including:

- ✔ Adjust brightness, contrast, saturation, and warmth as you wish.
- ✔ Tap the double-headed blue arrow in the picture to make the photo full screen so you can review your changes easily. (Tap the photo again to return to the adjustment screen.)
- ✔ Send the composite photo, via e-mail, with the settings you chose for size.
- ✔ Tap Save to save the composite photo in your Photo Library.
- ✔ Tap Done to exit the editing process without saving and return to the main menu screen shown in Figure 9-14.

I did not make any modifications, and the result is shown in Figure 9-21.

If you forget to tap the Save button, you get an onscreen warning so your results aren't lost.

Figure 9-21: Final result of using Pro HDR.

Pro HDR works as advertised and does a really good job in adjusting and saving a poor photograph with too much contrast and little or no detail in the shadows and highlights. A great application for $2.

Making panoramas with Pano

I bet many of you have probably stitched together photos from your digital camera to make a panorama. While it's satisfying to some degree, it isn't always easy to do manually, whether you're doing it in a program like

PanoStitcher or Photoshop, you probably never thought you'd be able to do this on your iPhone. Well, think again. After you purchase the app, locate the screen where it appears on your iPhone (see Figure 9-22 for an example).

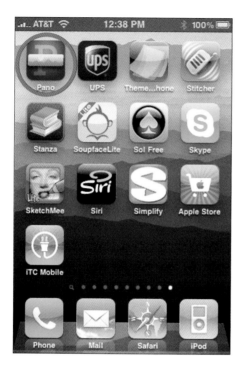

Figure 9-22: Finding the Pano app.

It's as easy as 1, 2, 3 (or as many photos as you want to stitch):

1. **Tap the Pano icon to start the application (Figure 9-23 shows the opening screen).**

2. **Tap the Orientation button that toggles the orientation for the panorama to landscape.**

 The photo number at the top of the screen advances with each shot you take.

3. **Tap the Shutter button to take the photograph.**

 The photo number advances to 2, and a semi-transparent overlay of the rightmost portion of the previous shot appears on the left of the screen, as shown in Figure 9-24.

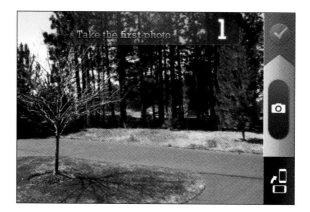

Figure 9-23: Ready to take the first photo of the panorama.

Overlay

Figure 9-24: Overlay to be matched in the next shot.

4. **Rotate your body to the right and position the camera until the overlay from the previous photo lines up with the same portion of the scene in the shot you're about to take. Tap the Shutter button to take the photo.**

 The photo number advances to 3. You can repeat Step 4 until you have all the shots you want.

5. **After you take the photos you wish to, tap the Done button (looks like a checkmark).**

 Pano begins creating the panorama. When Pano finishes processing, the completed panorama displays and saves to your photo album, as shown in Figure 9-25. A four-shot panorama should take less than 20 seconds.

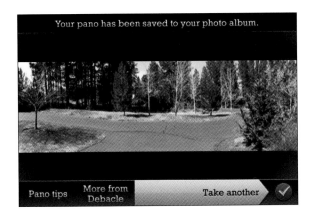

Figure 9-25: The finished result.

If you tap Pano Tips at the bottom of the screen, you see a list of tips and Frequently Asked Questions that you can peruse. Debacle is the name of the company that developed Pano; tapping More from Debacle shows some of its other products.

These are the basic steps for making a panorama. While you're shooting the individual photos, you can start over or even back up and retake a shot. This very professional and fun application makes taking panoramas with the iPhone very easy. The price is also right at $1.

Combining multiple photos into one image with Diptic

Here is an amazingly easy-to-use and inexpensive ($2) app that lets you creatively combine multiple photos into a single image. Diptic provides a number of patterns that allow up to four photos, in different orientations, to be assembled and individually edited into a single artistic display. It's a great way to tell a story in one image.

Here's a look at how it works.

1. **Tap the Diptic icon on your iPhone to start the app.**

 The first thing you see is a screen allowing you to choose the layout you wish to use, as shown on the left side of Figure 9-26. The current version of the app has four sets of layouts to choose from, obtained by swiping across each set of layouts to see the next set.

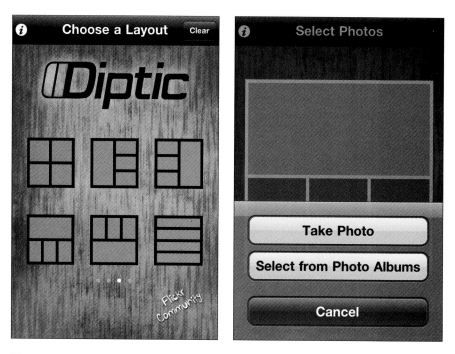

Figure 9-26: Opening Diptic screens.

Tapping the Info button at the top left will always give you directions for what to do on each of the screens.

2. **When you find the layout you like, tap it to select it. Then tap the individual pane you wish to start with, and a set of buttons appears as shown on the right side of Figure 9-26.**

After you choose a layout, you'll have five icons at the bottom of every screen that allow you to navigate to any operation in any order.

You can either take a photo with the iPhone camera or select a photo from your Photo Albums, which includes your Camera Roll. In this example I chose to pick a photo from my Camera Roll. Tap each empty pane and choose a photo to fill it. Figure 9-27 shows the result for this example.

Within each pane you can move the photo around with your finger to position it as you wish. You can also use the pinch-zoom gesture to make the photo larger or smaller.

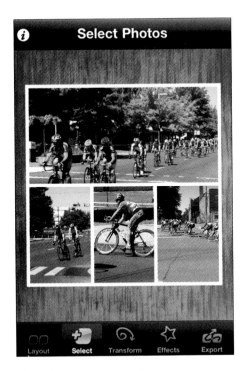

Figure 9-27: All four panes filled in.

3. **Tap the Transform button (for this example) at the bottom of the screen and then tap the pane that you want to transform (in this case the lone biker at the bottom).**

This produces the view you see on the left in Figure 9-28. You could also tap the Mirror Image button to turn the rider around and produce the screen shown on the right in Figure 9-28.

4. **Tap the Effects button at the bottom of the screen, then tap the pane to which you want to apply the effect.**

As you see on the left side of Figure 9-29, this allows you to change the brightness, contrast and saturation values for that pane.

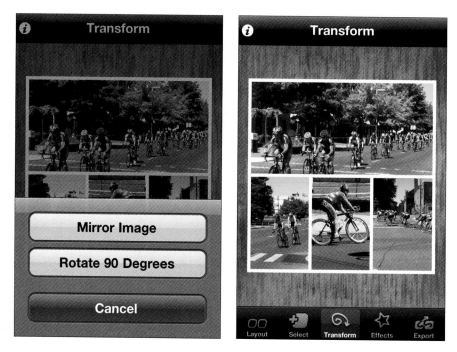

Figure 9-28: Transforming one of the panes.

5. **When you are satisfied with your changes, tap the screen away from the sliders.**

You can then select another pane and modify it.

You can also change all borders by tapping the Borders button in the top right corner of the screen. You get a set of sliders (see the right side of Figure 9-29). The top one adjusts the size of the borders, while the other three sliders adjust the red, green and blue components of the border color. (Or just press the black or white buttons for those colors.) When you are satisfied with your changes, tap the screen away from the sliders.

6. **Tap the Export button to get the screen shown on the left in Figure 9-30.**

7. **To save your work to your Camera Roll, tap the To Photos button in the top left corner.**

When the save is complete, you see the screen shown in the middle of Figure 9-30.

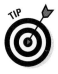

To share your work, tap the To Email button in the top right corner, then fill in the addressees, change the default message if you wish and tap the Send button. A set of four buttons appears in the lower part of the screen asking you to choose the photo size you wish to use in your e-mail. When you make the choice, the e-mail is sent.

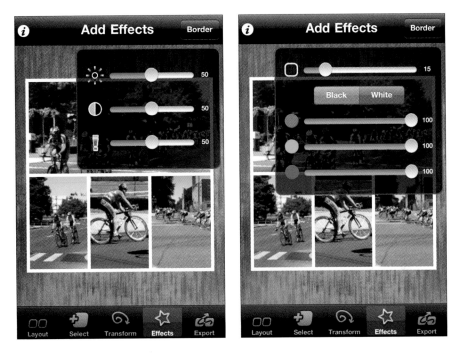

Figure 9-29: Editing a pane and changing borders.

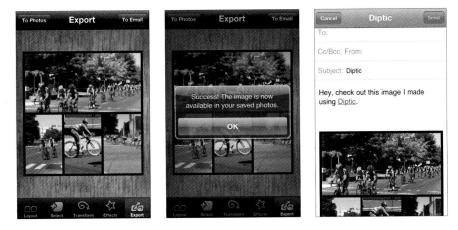

Figure 9-30: Using Export to save and e-mail your image.

As you can see, this app is easy to use. Best of all, you can use it right at the spot you took the photos and get them off to your friends to tell them your "photo story" for the day.

Shooting in low light with iNightShot

I know. If you don't have an iPhone 4, you're probably in a state of supreme jealousy. That's because the iPhone 4 has a flash, and the iPhone 2G, 3G, and 3GS do not. But that doesn't mean that shooting in low-light situations is out of the question. Several applications in the App Store can simulate flash and save a dull and dark photo.

One app I like is iNightShot, which gives you the chance to try several levels of simulated flash effects to find the one you like best. Here's how you use it:

1. **Tap the iNightShot icon on your iPhone to start the iNightShot application.**

 The iNightShot main menu displays, as shown in Figure 9-31.

Figure 9-31: The iNightShot main menu.

2. **Tap the Take a Photo from Camera button to use the iPhone camera or tap Select Picture from Albums to use a photo from your Photo Library.**

 If you choose to take a photo, Retake or Use buttons appear, as shown in Figure 9-32.

Figure 9-32: Choose Retake or Use.

3. **When you're happy with the photo, choose Use.**

 From this point, the interface is the same whether you took a new photo or chose something from your Photo Library.

 Figure 9-33 shows the original photo of an indoor, poorly lit scene. Figure 9-34 shows the scene in iNightShot with a flash effect added.

 Along the bottom of the screen, you see the following buttons:

 - *No Flash:* Shows the original photo for comparison.
 - *Flash:* Gives the photo the lowest level of flash effect.
 - *More Flash:* Gives the photo a higher level of flash effect.
 - *High Flash:* Gives the highest flash effect level.
 - *Modes:* Changes the look of the photo. Here are your three choices:

 Color: Keeps the photo in color.

 B&W: Changes the photo to black and white.

 Sepia: Gives the photo a sepia tone.

4. **After you finish, tap the Save Photo button.**

Although it doesn't always make an improvement, it's rather amazing how much this application can do for a poorly lit scene. Remember, I'm talking about a camera in a cell phone. iNightShot adds a flash effect to a scene after the fact. Not bad and certainly worth a $1.

Figure 9-33: Original photograph.

Figure 9-34: After High Flash effect added.

Having Fun with Your Photos

*R*emember the old saying "All work and no play makes Jack a dull boy?" Well, the same is true for photography. You have all sorts of serious reasons for taking photographs. Perhaps you're documenting an event for your family, catching a playful mood with your loved one, or just capturing a scene because it evokes a particular feeling when you see it. All that is the "work" part of photography.

Wouldn't it be great if there were some applications out there that let you have some creative fun with your camera? Luckily, apps are available — both free and for a fee — that let you unleash your humorous side. I show you a few apps to get you started, then you can browse the App Store at your leisure to find more that you like.

Tricks with Your Pics

The changes you can make to your photos span a wide variety of digital effects. Sometimes, an app can change the look of a person's face. Other times, an app lets you change the overall color cast or tint of a photo, lets you add sepia tone, makes the photo black and white, or turns people into caricatures.

Changing faces with Soupface

Although most of us aren't making false identification papers or passports, we can all enjoy morphing people's faces and seeing what we come up with. Soupface can do this, and the application exists in a Lite version (free!) and a fee version that costs a whopping $1.

Soupface lets you choose a photo (friend, self, family, or whomever) and then blend it with another face. For the examples in this section, I use two of the faces that come with the application. Figure 10-1 shows the Make Soup screen you see when you open Soupface by tapping its icon. Any time you want to return to this screen, tap the Make Soup button.

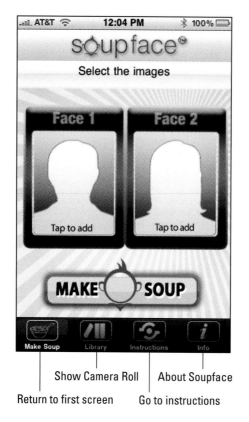

Figure 10-1: The Soupface application.

Here's how you use Soupface:

1. Tap the Face 1 image to select the face you wish to use.

A set of buttons appears, as shown in Figure 10-2.

- *Use Photo from Library:* Tap this button to select an image from your Camera Roll or Photo Library.

- *Take Photo with Camera:* Tap this button to take a photo using the standard iPhone camera interface used in the Camera app (see Chapter 1).

- *Use Database Images:* Tap this button to use the vendor-provided images.

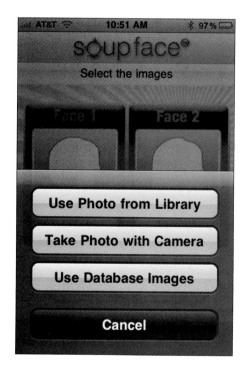

Figure 10-2: Buttons for selecting an image.

2. **After you select an image, use a pinching or spreading movement of your fingers to shrink or enlarge the image so that the eyes and mouth of the face match the overlays.**

 This capability allows you to use images that would otherwise be too large or too small to match the overlays. See Figure 10-3 for an example. Try to match the overlays as closely as possible. The better the match, the better the result.

3. **After you finish, tap the Done button to return to the Make Soup screen with your image in the Face 1 position.**

4. **On the Make Soup screen, tap the Face 2 area (see Figure 10-4).**

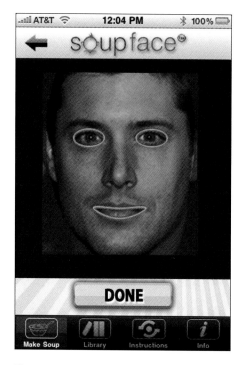

Figure 10-3: Setting the eyes and mouth areas.

5. **Choose one of the options on the menu that appears and then adjust the image you select by using your fingers to shrink or enlarge it to match the eyes and mouth overlays.**

6. **When you're finished, tap the Done button to return to the Make Soup screen with both Face 1 and Face 2 filled in.**

7. **Tap the Make Soup button, as shown in Figure 10-5, and the magic begins.**

8. **Tap Save to save your new image.**

 Figure 10-6 shows the finished photo.

9. **(Optional) Tap the Share button to share your photo.**

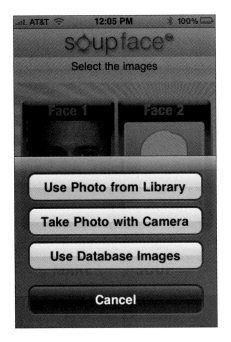

Figure 10-4: Choosing the second face to use.

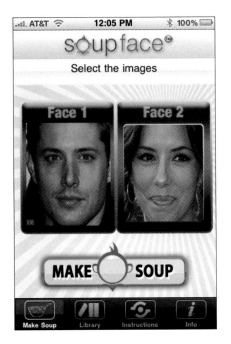

Figure 10-5: You're ready to make soup.

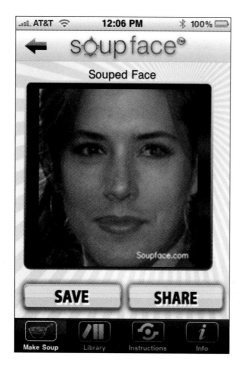

Figure 10-6: The finished face.

That's all there is to it. The more you practice the better you should get.

Using selective color with ColorSplash

Here's an app that's fun to mess around with; ColorSplash can actually enhance the message you wish to convey in your photograph. Photographers use Photoshop for this, but this ColorSplash lets you do it on your iPhone and costs only $2!

Basically, using the idea of selective color (which you've probably seen on TV or in print) allows you to turn a color photograph into black and white and then lets you add the original color back into parts of the photo to draw attention there. It's an artistic technique.

An example of this appears on the opening screen of the ColorSplash app, as shown in Figure 10-7, which also shows the app's buttons.

Restore Normal Coloration button

Operations button Colored Area button

Help button Brushes palette

Multi-Undo
button

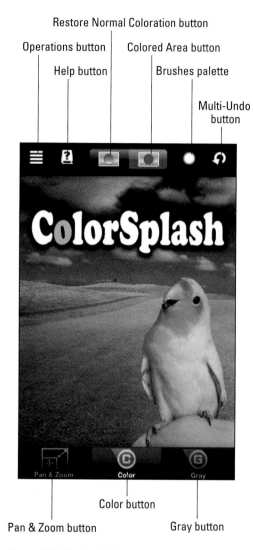

Color button

Pan & Zoom button Gray button

Figure 10-7: The ColorSplash main menu.

I highly recommend looking at the first tutorial, which is built in to the app.
You'll then be prepared to make the best use of ColorSplash.

The buttons in Figure 10-7 are as follows, from left to right and top to bottom:

- **Operations:** Tapping this button brings up an Operations menu including Save, Start New Session, Load Previous Session, and Settings.

- **Help:** The inline Help button opens a tutorial that will familiarize you with ColorSplash.

- **Colored Area:** Tap the red Colored Area button to show (in red) the exact area(s) that has been colored.

- **Restore Normal Coloration:** Tap this button to the left of the red Colored Area button to restore the original color.

- **Brushes Palette:** This circular white button brings up the Brushes palette to pick the size and opacity of the brush you use.

- **Multi-Undo:** Each tap undoes another operation.

- **Pan & Zoom:** Allows you to move and zoom the photo. Shortcuts can do this but, until you get used to the app, you might want to use this button.

- **Color:** Each touch of the Color (C) button adds color.

- **Gray:** Each touch of the Gray (G) button removes color.

Here's the basic process you can follow for your photos. While you gain experience, you'll undoubtedly find many other paths that work.

1. **Launch the ColorSplash app.**

 Immediately after the main menu is displayed (see Figure 10-7), you will be asked if you wish to take a photo or load an image from your Photo Library.

 If you choose to take a photo, a screen similar to the Camera app appears.

2. **Take a new photo or select one from your Photo Gallery or Camera Roll.**

 Your photo displays with all color removed, similar to Figure 10-8.

3. **Using the buttons described previously in this section, add color back into your photo.**

4. **When you're satisfied, tap the upper-left Menu button to return to the main menu (see Figure 10-9).**

5. **Select Save Image.**

 Figure 10-10 shows the result.

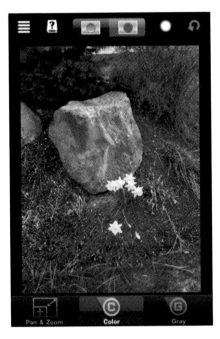

Figure 10-8: First working screen showing the photo in black and white.

Figure 10-9: Menu choices for the action you want to perform.

Figure 10-10: Colorized image result.

The Settings screen (see Figure 10-11) is where you can set your preferences, such as showing the brush size slider and choosing whether you want to save the original photo.

Naturally, there are more features in this app, but I hope this brief introduction gives you an idea about the things you can do with ColorSplash.

Figure 10-11: Settings screen.

Showing Off Your Photos

Some apps, such as ColorSplash and Soupface, have the capability to let you share your photos from within the application. If an app you're using doesn't, don't despair; it just means you have to go to a sharing Web site to do this. Whether the app let's you share from within or not, you can still let the world, or at least the part you know, have a look at your creations.

Using Flickr for sharing

If you have a Yahoo! account (if not, it's free at www.yahoo.com; click the Sign Up link at the top of the Web page and follow the instructions), it's easy to access Flickr.com from your iPhone and share your photos with friends and family — or everyone if you choose. The Flickr iPhone app is free, and when you tap the Flickr icon, the iPhone screen looks similar to Figure 10-12.

Search box

Information button Photo button

Recent button You button Contacts button

Figure 10-12: Flickr app opening screen.

As you can see, you can do the following:

- ✓ Tap the Information button (*i*) to go to the information screen where you can see the Terms of Service for Flickr, a list of other Yahoo! applications, and other informational items.

- ✓ Tap the Camera button (camera icon with arrow on top) to take a photo or video or upload a photo or video from your iPhone's Camera Roll or Photo Library.

- ✓ Perform a search for photos and videos in the Search box.

- ✓ Tap the Recent button to see your recent activity and uploads.

✔ Tap the You button to connect to your Flickr account on Yahoo! where you can see your uploaded photos and videos in what is called Your Photostream, as shown in Figure 10-13. Your username will appear after Hello. If you have already uploaded photos or videos, Your Photostream will show those uploads.

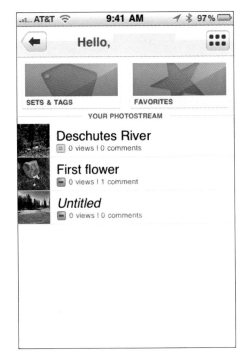

Figure 10-13: Tapping the You button shows your photo/video uploads.

✔ Tap the Contacts button to see an alphabetical list of your contacts from Yahoo! Mail, Google Mail, and Windows Hotmail. Creating the list must be done in your Flickr account on the Web.

To upload photos or videos, do the following:

1. **From the Flickr app opening screen (refer to Figure 10-12) tap the Camera icon at the upper right.**

 A set of buttons appears, as shown in Figure 10-14.

Figure 10-14: iPhone screen showing choices for uploading.

2. **For this example, tap the Upload from Library button.**

 The contents of your Camera Roll and Photo Library display. To select one of your photos or videos, tap a thumbnail.

3. **On the Details page that appears showing the photo you selected, fill in the image's information, such as title, description, and privacy level for viewing.**

 An example is shown in Figure 10-15. If you wish to upload additional photos, tap the Add Item button and select each image.

4. **To upload the images to your account on the Flickr Web site, tap the Upload button.**

 After you upload your photos or videos, you can tap the You button to see the result of the upload. Figure 10-16 shows an example.

Naturally, you can also access your photos from your computer or anywhere in the world at www.flickr.com.

Figure 10-15: Details page for photos you're uploading.

Figure 10-16: Displaying your uploaded photos.

Using Shutterfly for sharing

Shutterfly is a free iPhone app that lets you upload, view, and share your favorite photos no matter where you are. There is also a Shutterfly Web site (www.shutterfly.com) where the photos are actually stored. The storage is unlimited and best of all, free. On the Web site, you can create photo books, cards, calendars, and prints, although these are not free.

Figure 10-17 shows the Shutterfly sign-in screen you see after tapping the Shutterfly icon on your iPhone. Either sign in or create a new account if you don't have one.

Figure 10-17: iPhone opening screen for the Shutterfly app.

After successfully signing in, the screen in Figure 10-18 appears showing any albums you currently have. Tap on the right-facing arrows to open an album and see the contents. You then can tap the Play button to start a slideshow.

The screen also shows a set of icons at the bottom that allow you to perform the following operations:

- Tapping the Camera icon opens the standard iPhone camera interface (see Chapter 1 if necessary). After taking a photo, you're offered the choice of using the current photo or retaking the image. You then upload the photo.

- Tapping the Upload icon opens a screen containing your Camera Roll and Photo Library. You choose a photo and the Shutterfly album you want to put it in and then start the upload process.

- Tapping the Queue icon presents a screen showing the progress of the photos you're uploading.

- Tapping the Settings icon allows you to set the maximum size of the thumbnail cache on your iPhone and turn the shake viewer on or off. With the shake viewer on, shaking the iPhone causes the slideshow to advance.

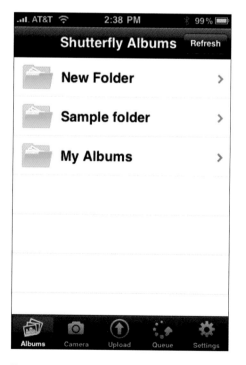

Figure 10-18: The Shutterfly Albums screen.

To upload a photo:

1. **Tap the Upload icon to see your Camera Roll and Photo Library and then select a photo by tapping its thumbnail.**

 The Preview screen shown in Figure 10-19 appears.

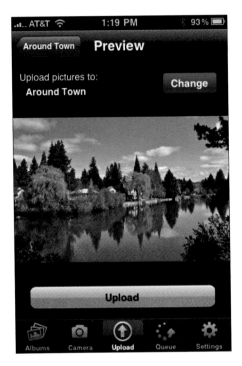

Figure 10-19: Preview screen for uploading a photo.

In this case, the photo will upload into the Around Town album. To use another album, including a new one, tap the Change button. You then see the screen on the left side of Figure 10-20. You can tap a line to select another album or tap the Add (+) button to create a new album, which is what I did.

The screen on the right side of Figure 10-20 is where you type the name of the new album. This is where I created a Sights in Bend album.

2. **When you're satisfied with the name and location, tap the Save button.**

 You return to the Preview screen with the new album as the destination.

3. **Tap the Upload button to start the process.**

 If the photo isn't large, the upload completes quickly. You can then upload another photo by repeating these steps.

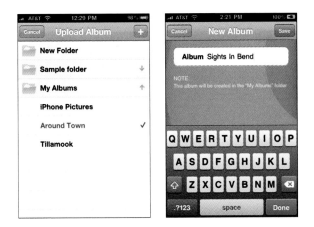

Figure 10-20: Creating a new Shutterfly album on the iPhone.

To check the progress of a longer upload, you can tap the Queue icon. An example is shown in Figure 10-21.

Figure 10-21: The Queue screen showing an upload in progress.

You can access the Settings screen by tapping the Settings icon at any time. An example is shown in Figure 10-22.

Figure 10-22: The Settings screen.

That's all it takes to send photos you've just taken (or previously saved in your Camera Roll or Photo Library) to the Shutterfly site for sharing with your friends and family.

Part V
The Part of Tens

The 5th Wave By Rich Tennant

The Levines Edit Their African Safari Album

"Do you think the 'Hidden Rhino' photo should come before or after the 'Waving Hello' photo?"

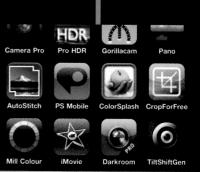

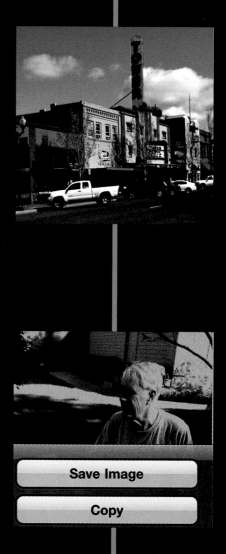

*W*elcome to the Part of Tens, the part of all *For Dummies* books where you find additional resources and recommendations. In this book, the resources help you get the most enjoyment from your iPhone photography.

In Chapter 11, I point you to some Web sites, blogs, and forums that enhance your capabilities with the iPhone camera and enrich your knowledge of photography. The places you learn about are also great resources for answering your questions and sharing information that's useful in every photographic situation.

Chapter 12 is a treasure trove of helpful hints, photographic tips, and shortcuts to make your use of the iPhone even more productive.

Ten Terrific Resources for iPhone Photography

*R*egardless of the photographic knowledge you accumulate, there always seems to be something more to learn. I've certainly found this to be true, especially when using a camera in a cell phone, which requires some sophistication.

How do you develop that sophistication? Just visiting a forum is a great way to get questions answered and gain insight into areas of iPhone photography you may not have thought about. In this chapter, I give you ten very useful resources to make your photos the best they can be. While the iPhone gathers even more converts, I'm sure the number of sites devoted to it and to iPhone photography will grow. With the arrival of the iPhone 4, new products and new information are almost a daily event. There's no better way of keeping up to date than using Web resources.

The Unofficial Apple Weblog

www.tuaw.com

TUAW is a popular site that covers most things Apple. One part of the site is devoted to the iPhone. Tips, reviews, and new equipment often make their appearance here before anywhere else.

iPhography

http://blog.iphography.com

At this site, you can find the latest information on the iPhone, photo and video applications, photographic tips, and application reviews. It's a great place to spend some time each day.

iPhone Alley

www.iphonealley.com

iPhone Alley is one of my very favorite sites to browse while I have my morning coffee — to tell you the truth, I check it several times a day. The site's layout is convenient. Each featured article has a preview that helps you decide whether you want to read more. You can then go to the full article and, in the case of new iPhone apps, follow a link to iTunes for information and downloading. iPhone Alley also has podcasts at least once per week on timely subjects and a separate section devoted to tips.

iPhone Central

www.macworld.com/weblogs/iphonecentral.html

As you can see from the URL, this is a MacWorld service, and it does a great job of keeping you informed of happenings with the iPhone and the App Store via an entire section of tips, tricks, and how-to's.

iPhoneography

www.iphoneography.com

A great iPhone photography and videography resource, the iPhoneography Web site contains a user forum for posting photography questions, a developers' corner allowing app developers to interact with each other (and users), a comprehensive archive of past articles, and a photography blog. It's well worth a visit.

iPhone 4 Forum

www.iphone4forum.net

Here's a relatively new Web site devoted to sharing information on the iPhone 4 and iPhone 4 photography, such as tips, tricks, general discussions, iPhone 4 apps, and hardware capabilities.

Just Another iPhone Blog

http://justanotheriphoneblog.com/wordpress

This comprehensive Web site is devoted to the iPhone, has an excellent area for iPhone tricks and tips, and an entire subsection devoted to iPhone photography and videography. I highly recommend checking it out regardless of the slightly self-deprecating title of the Web site.

The iPhone Blog

www.tipb.com/iphone

An extensive and well laid out Web site that includes a forum, podcasts, reviews, how-to's, and many articles in an archive that stretches back three years. If you only want to go one place for information and insight, you can't go wrong making it this one.

Apple Discussions Forum — iPhone

http://discussions.apple.com/category.jspa?categoryID=201

Of course, you can always head to the manufacturer for a wealth of information. I find this Apple site easy to search and usually full of just the information I'm looking for.

The Apple Core — ZDNet

www.zdnet.com/topics/iPhone?tag=header;header-sec

Often more news and rumor than outright tips and techniques, this blog is still a useful source of information about the iPhone.

12

Ten Helpful Hints, Tips, and Shortcuts

In This Chapter

▶ Improving the composition

▶ Tips and tricks for the iPhone

▶ Shortcuts for iPhone photography

*I*n this Part of Tens chapter, I show you some Web sites that present specific tips. Additionally, I give you some tips and shortcuts that I find helpful.

While I furnish this information to assist in using the iPhone camera, these techniques are often useful in any kind of photography. Some of these hints and tips may be ones you already know and use. Hopefully, a few will present a new perspective on an old problem and help you more fully enjoy your iPhone photography.

If It Doesn't Look Right, Get Closer

One simple tip to help you get better photos to start with is to get close to your subject. This technique is true no matter what camera you're using. It's just perhaps more true with something like the iPhone.

Of course, sometimes, getting physically closer to your subject is impossible, if not downright dangerous. In Chapter 8, I discuss the difference between digital and optical zoom and that if you must use digital zooming, you're often better off using software, such as iPhoto, after the photo is captured. If you're fortunate enough to have an optical zoom lens for your iPhone (such as the ones I describe in Chapter 8), by all means use them. For example, if you're shooting at the zoo, zoom in on that monkey's face instead of always taking a wider-angle shot.

Just keep reminding yourself that in a wide-angle shot, what you're seeing with your eyes may be several miles wide, but it's all going to be squeezed down onto a three-inch screen at the resolution of the iPhone camera! Get in the habit of seeing what the shot looks like from different vantage points. That's something a zoom lens can't do. I often find that a marginally good shot from one angle becomes really exciting from another, which opens up all kinds of creative possibilities.

Like all rules, rules of composition aren't hard and fast. I've broken a few of them on occasion but always with a purpose; perhaps the scene appealed to me more by breaking a rule. Don't be afraid to try things. After all, it isn't film, it's erasable memory. Experimenting is how we learn what we like, what we don't like, and how to get better at capturing the good stuff.

Using a Folder for Your Photography Apps

If you're like me, you can quickly accumulate a number of helpful photography apps for your iPhone, enough so that finding one of them in particular can be time-consuming. This is frustrating when you're trying to take a quick photo with a particular app. Enter iOS4 folders.

Just like folders on your Mac or PC, the folders introduced in iOS4 are containers that help alleviate screen clutter and organize like-apps so you can find them easily. Figure 12-1 shows the contents of my photography apps folder.

The icon at the top left of Figure 12-1 is the folder itself, with room to show nine tiny thumbnails of the apps inside. It also has a name, Photography in this example, and there can be up to 16 folders on each screen. The folder can actually accommodate 12 apps before it's full. If you're good at math, you realize that, with folders, you can have 192 apps on one screen.

You open a folder by a single tap on its icon. Figure 12-1 shows my iPhone 4 screen with the Photography folder open. I can now tap the icon of any contained app, and it will start. To close the folder, tap the folder or in any empty space on the screen.

You must be running iPhone software version 4.0 or later for folders to be available. Not sure if you are? You can check by choosing Settings⇨General⇨About and looking in the Version entry.

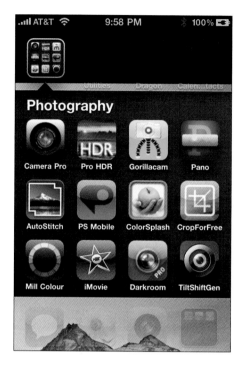

Figure 12-1: Grouping photography apps in a folder.

To create a folder:

1. **Go to the iPhone screen where you want to make a folder.**

2. **Press and hold on the first app you want in the folder and slide the app icon onto the icon of the second app you want in the folder.**

 A folder is automatically made for you with a name based on the genre of the first app. This name can be changed at any time. You can have up to 12 apps in any folder.

3. **To delete a folder, drag all the apps out of it.**

 The folder then disappears.

If you're creating many folders, it's a lot easier to do so by clicking the Apps tab of iTunes with your iPhone connected. You can then use the mouse instead of your finger to move things around and easily see any of your screens.

Stabilizing Your Photo-Taking

In Chapter 9, I discuss camera applications that are meant to eliminate or reduce camera shake. If you prefer to use the standard Camera app, you can still stabilize the iPhone.

Like many of the buttons on iPhone applications, the Shutter button in the Camera app operates on the lifting of pressure not the applying of pressure. Remembering this subtle difference can reduce camera shake tremendously.

While looking at the screen and composing your photo, go ahead and press and hold the Shutter button. As long as you continue to hold the button, you can adjust your composition and, on the iPhone 3GS or iPhone 4, tap a segment of the screen to adjust focus and white balance. When things are the way you want, gently lift your finger from the Shutter button. Nice shot!

Having Fun with Your Contacts' Photo

You probably know that you can take a photo of someone with your iPhone or any camera (including the camera in your Mac) and then add that photo to the Contacts listing for that person (or any other if you're feeling devilish).

For a fun effect, try the following:

1. **Get on one side of a window or any pane of glass and have the subject of the photo get on the other.**

2. **Have the person mush his face against the glass, or put his hands on the glass as though trying to get out.**

3. **Take the photo and place it in the Contacts listing for that person.**

When you get a call from that person, the photo appears, and the caller looks as though he's on the inside trying to get out.

Being Aware of Lighting

Our eyes are far better at adjusting for high-contrast scenes than any camera, especially the iPhone camera. One solution, of course, is to compose your scene with the extreme you're not interested in (highlights or extreme shadows) outside the camera's field of view. That's about all you can do with the iPhone and iPhone 3G, but what if you're interested in the entire range of light.

On the iPhone 3GS and iPhone 4, you can tap the screen to focus on a midtone area (not deep shadow and not bright highlights), which also changes the white balance. This can allow the camera to capture adequate shadows and all the highlights (Chapter 6 discusses why this is vital), which can be adjusted in iPhoto or some other photo-editing application.

Give this a try the next time you face a high-contrast scene and can't wait for better lighting.

Sending Full-Resolution Photos from Your iPhone

When you take a photo with your iPhone, it is saved to your Camera Roll or Photo Album at full resolution. In the case of the iPhone and iPhone 3G, that's 1600 x 1200 pixels; for the iPhone 3GS, it's 2048 x 1536; and for the iPhone 4, it's 2592 x 1936.

Although that's not a great deal of resolution, you certainly want to maintain it all if you plan to share your photos with anyone. The iPhone software makes it very easy to share your photos, via e-mail or MMS, with friends and relatives. But often, those photos send at 800 x 600 resolution. That's quite a reduction.

To keep the full resolution when you send photos, you simply copy and paste the photos into your e-mail. Here's how:

1. **Go to your Camera Roll or Photo Library where the photo or photos are stored.**

 To copy just one photo, press and hold a thumbnail until a Copy pop-up appears, as shown in Figure 12-2. Tap the pop-up to copy the photo at full resolution.

 To copy multiple photos, tap the upper-right action icon (the curved arrow), tap each thumbnail you want to copy, and then press the Share button at the bottom, as shown in Figure 12-3.

2. **Two buttons appear onscreen: Email and MMS. Tap the button for the destination you wish to use.**

 For this example, I chose to share via e-mail.

3. **Fill in the To: address, Subject line, and any message you wish on the e-mail form that opens with your photos pasted in.**

4. **Tap Send.**

 Four buttons appear onscreen so you can select the size of the image you wish to send, as shown in Figure 12-4.

5. **Tap the appropriate choice, and the e-mail is sent.**

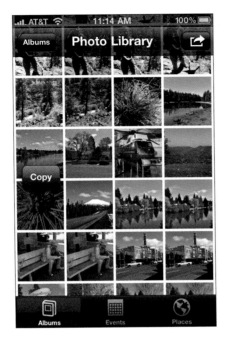

Figure 12-2: Copy pop-up.

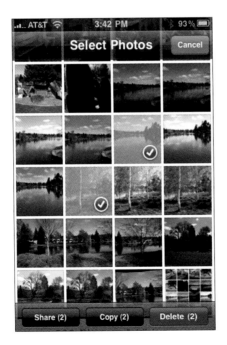

Figure 12-3: Multiple photo copy operation.

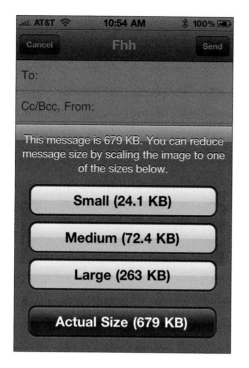

Figure 12-4: Sending an e-mail with a photo pasted in.

E-mail photos are sent at the resolution you choose. MMS photos are sent at their original size. If you send too many photos — or very large photos — in one e-mail, the e-mail may not go through.

Saving Images

I'm sure you've surfed the Web and seen an image you wanted to capture. On the iPhone it's easy. Just press and hold on the image until you see the screen shown on the left side of Figure 12-5. Tap the Save Image button, and the Web image saves to your Camera Roll.

Or maybe you've received an e-mail that contains images you want to save. To do so, just press and hold on the image until the Save Image screen appears. Tap the Save Image button (shown on the right side of Figure 12-5), and the image saves to your Camera Roll.

You can then go to your Camera Roll and do the usual things: share the image via e-mail, modify it in one of your applications, or save it to iPhoto '09.

Figure 12-5: The Save Image screens.

Making a Contact's Photo Appear Full Screen

You might like to have your contact's photo appear full screen whenever she calls you on the iPhone. It's super easy to do.

Open the Contacts app and get to the contact you wish to work on. (If there's no photo yet, go take one!) When there is a photo on the contact page, follow these steps:

1. **Tap the Edit button in the upper-right corner.**

2. **Tap the photo to select it.**

3. **Tap the Edit Photo button.**

 The photo appears full screen, and you are asked to move or scale it. There's no need to do anything.

4. **Tap the Choose button. The full-screen photo will be saved.**

5. **Tap the Done button.**

 The next time that person calls, you will see the full-screen photo on your iPhone.

Taking a Self-Portrait with Your iPhone

If you have an iPhone 4, you already know it has a front-facing camera. To take a self-portrait, you just open the Camera app, tap the Change Camera button to select the front camera, line yourself up in the iPhone 4 screen, and press the Shutter button.

But what about the other iPhone users. Here's a quick solution that may be worth a few laughs. If you're stuck, need to take a self-portrait, and are without a tripod or anything else to steady the camera, do this:

1. **Open the Camera app and press and hold the Shutter button.**
2. **Turn the iPhone camera toward you and smile.**

 You can use the Apple logo as a mirror.
3. **Gently release your finger from the Shutter button.**

You'd be surprised how good a job you can do. It may take a few tries; just erase and do over.

Mind the Background

All of us, at one time or another, have fallen victim to the dreaded background goof, and you end up with a pole or tree growing out of your subject's head. At the time you took the photo, perhaps you were so focused on the subject you forgot about everything else.

In Chapter 4, I mention that we see in 3D and objects behind the subject don't seem so objectionable because of the depth between them. But the camera sees in 2D! You close one eye to help with composition, now you have another use for it; checking for stray objects in the background.

Another useful trick iPhone 3GS and iPhone 4 users can take advantage of is to selectively focus on a brightly lit subject. This throws the background into shadow, which can help keep a distracting background in check.

Of course, changing your location and angle can help you avoid this problem, too.

Index